W9-BIK-995

Glorious GARDEN FLOWERS *in* WATERCOLOR

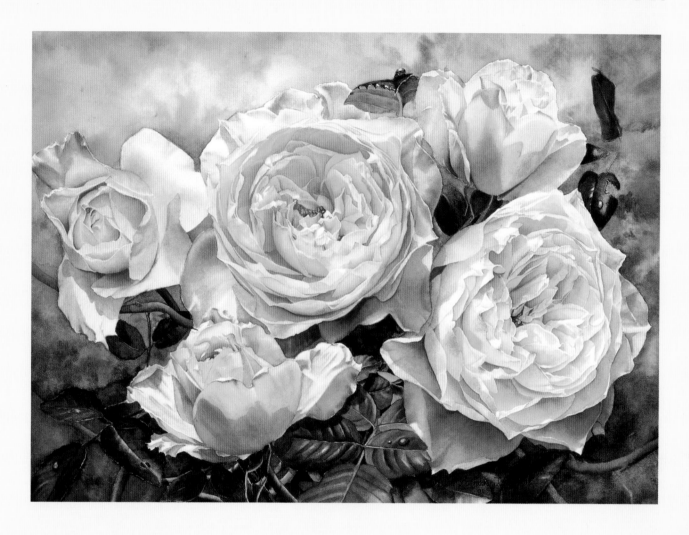

SUSAN HARRISON-TUSTAIN

NORTH LIGHT BOOKS
CINCINNATI, OHIO

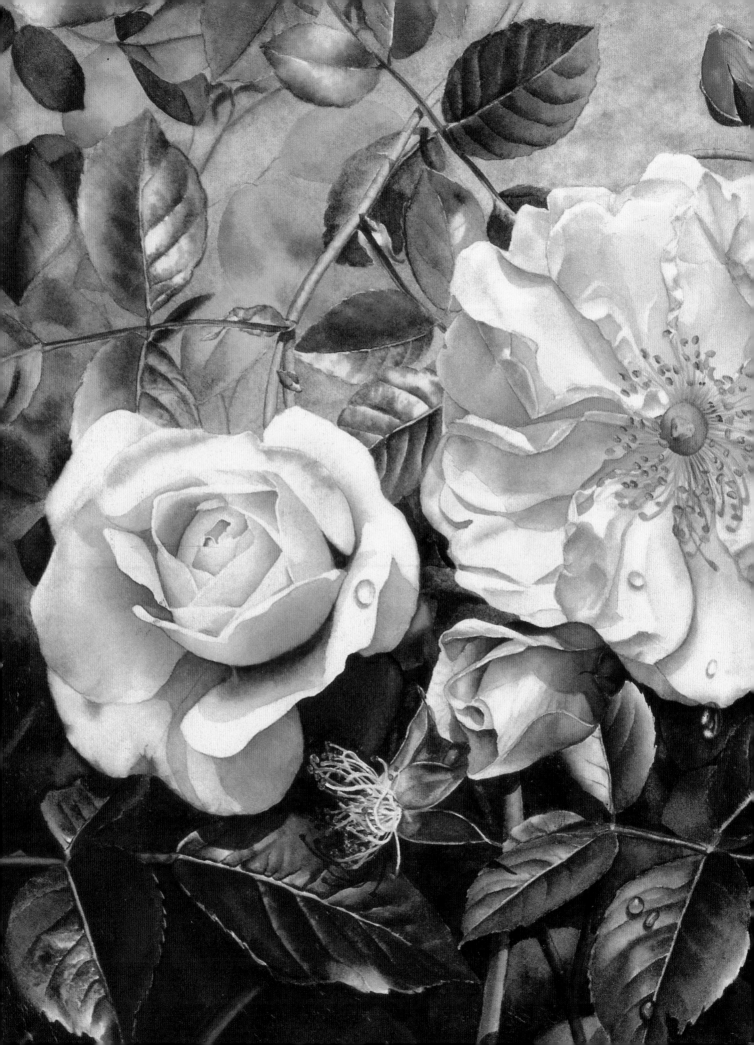

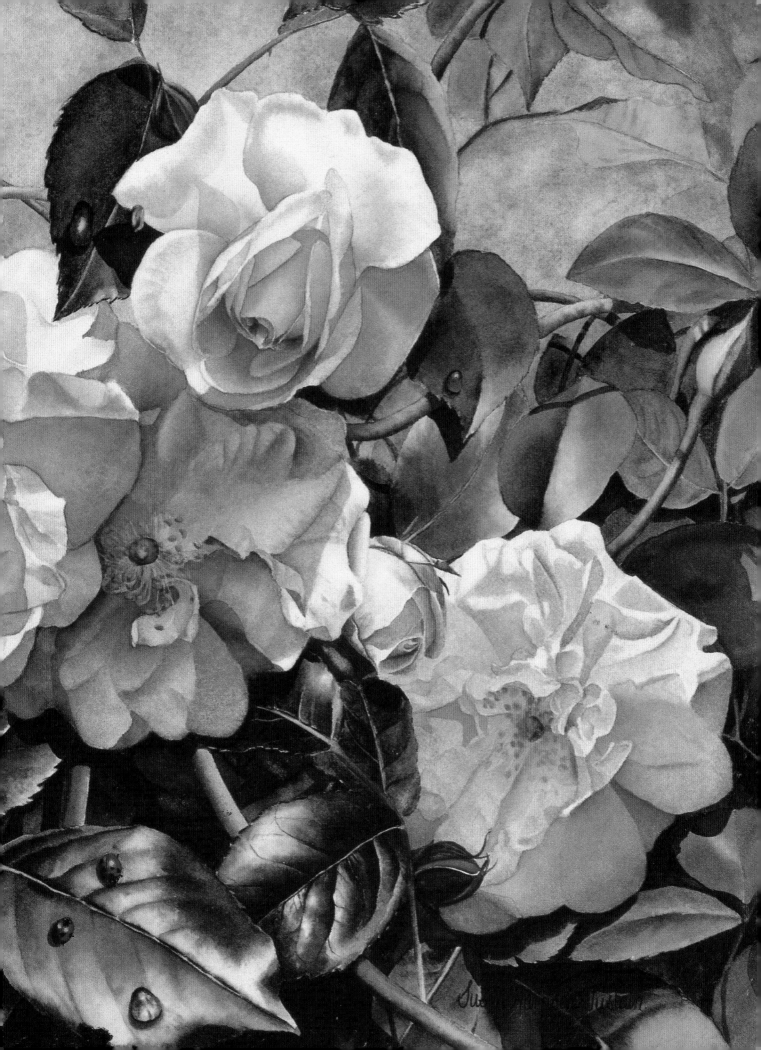

(pages 2-3)
OLD RAMBLING ROSE
*watercolor on Arches 140-lb. (300 g/m²) hot-pressed
paper, 14″×20″ (36cm×51cm), private collection*

Other fine North Light Books are available from your local bookstore, art supply store or direct from the publisher.

03 02 01 00 99 5 4 3 2

Library of Congress Cataloging-in-Publication Data

Harrison-Tustain, Susan.
 Glorious garden flowers in watercolor / Susan Harrison-Tustain. —1st ed.
 p. cm.
 Includes index.
 ISBN 0-89134-828-X (hardcover : alk. paper)
 1. Flowers in art. 2. Watercolor painting—Technique. I. Title.
ND2300.H37 1999
751.42′2434—dc21 98-18375
 CIP

Edited by Jennifer Long
Production edited by Amanda Magoto and Amy J. Wolgemuth
Designed by Brian Roeth

I dedicate this book to my family:
Richard, Glen, Shelley, Mum and Dad,
Doreen and Steven.
Thank you for believing in me.

Susan Harrison-Tustain was born in 1956 and raised in New Zealand. From a very early age, her mother, Florence, offered the encouragement and enthusiasm that allowed Harrison-Tustain to develop her creativity. Harrison-Tustain has needed no formal training; she has developed her ability through simple observation and through reading countless books like this one. Passionate about art, she has an intuitive gift she loves to share with others.

Painting professionally since 1992, Harrison-Tustain is recognized as one of New Zealand's leading floral artists. Her career has snowballed quickly to the stage where queues for her exhibitions start two hours before the doors open! Her paintings sell out immediately. Unable to increase the output of her original work, she now produces strictly limited-edition prints of her best work to meet some of the demand.

Harrison-Tustain's work often appears on the cover and within the pages of *The New Zealand Gardener*, New Zealand's leading garden magazine. She and her paintings have also been featured in many other magazines as well as on *Television New Zealand*. Her work is represented in many collections in New Zealand, Australia, the United States, the United Kingdom, France and Italy.

Harrison-Tustain gathers inspiration and subject matter from her local surroundings and her extensive travels—from her beautiful, clean, green New Zealand to the United Kingdom, Italy and her great passion: the village streets, gardens and countryside of Provence.

She lives with her husband, Richard, and children, Glen and Shelley, in the New Zealand countryside, close to the picturesque coastal town of Tauranga. Contact Harrison-Tustain via E-mail at (harrison-tustain@clear.net.nz).

ACKNOWLEDGMENTS

This book has been a major part of my life for the best part of two years. Special thanks to my family and friends who have been very understanding, supportive, encouraging and enduring. Richard, Glen and Shelley—you have coped admirably with my "time out" from everyday life. Richard, your practical help and in-depth knowledge of so many subjects has been invaluable; this book wouldn't have been possible without you. I am truly blessed with two beautiful children; Glen and Shelley, your enthusiasm is infectious! Many thanks to Dorna Crowther and Janette Fullerton for being there when I've needed that extra word of encouragement. To David Brownrigg, for your ability to see the obvious solution—"You don't need confidence; just do it!" I'm sure your faith in me helped me to rise to the challenge.

A huge thank-you goes to my late mother, Florence Harrison, who passed away when I was seventeen. Those formative years spent with her set me on this path where I have found fulfillment and joy. "Thank you" just doesn't seem enough. Without her love and enthusiasm, I wouldn't have explored my creativity.

A very special thanks to my editors and designers at North Light Books: Rachel Wolf, Pam Seyring, Joyce Dolan, Jennifer Long, Amanda Magoto, Amy Wolgemuth and Brian Roeth, who have skillfully woven this book together. Your collective input is much appreciated and has made writing this book a genuine pleasure.

BRANDY AND THE
MONARCH BUTTERFLY
watercolor on Arches 140-lb. (300 g/m²) hot-pressed watercolor paper, 12½" × 16" (32cm × 41cm), private collection

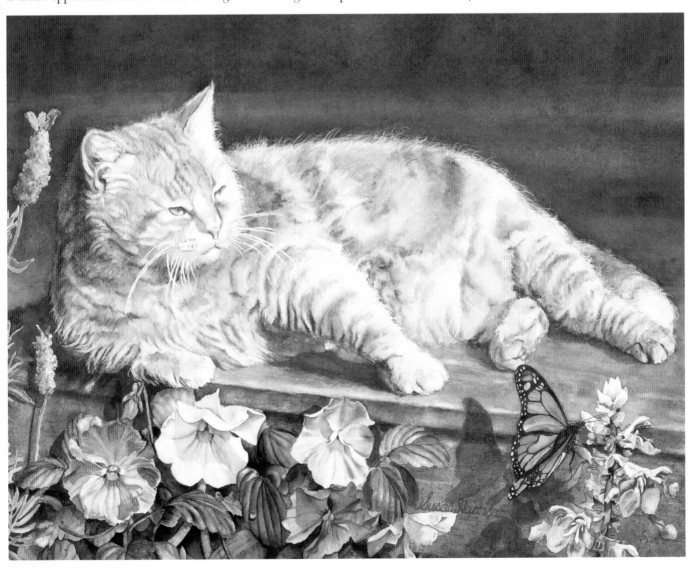

INTRODUCTION 11

CHAPTER 1

Tools and Materials *12*

Get the best advice on paint, brushes,
paper and other supplies for floral
watercolors.

CHAPTER 2

Familiarize Yourself
With Color Behaviors...... *20*

Learn about transparent, opaque and sedimentary
pigments as they relate to flower painting.

CHAPTER 3

Watercolor Techniques
for Florals *28*

Master Susan's unique priming method—along with
many other techniques—to create rich, transparent
darks, delicate lights and glowing brights.

CHAPTER 4

Floral Textures
Step by Step . 52

Follow along with these quick demonstrations to
create a wide variety of textures, from delicate petals
to shiny leaves.

CHAPTER 5

Adding Life to
Your Florals 72

Learn to paint the realistic details that
make your paintings come alive, such as
dewdrops, chewed leaves and ladybugs,
then incorporate them in a complete
painting demonstration.

CHAPTER 6

Painting Florals
With Character 96

Study these stunning step-by-step
demonstrations as
Susan shows you how to
combine the tech-
niques you've
learned to create
glowing floral paintings that capture
the essence of the flower.

GALLERY . 118

CONCLUSION . 125

INDEX . 126

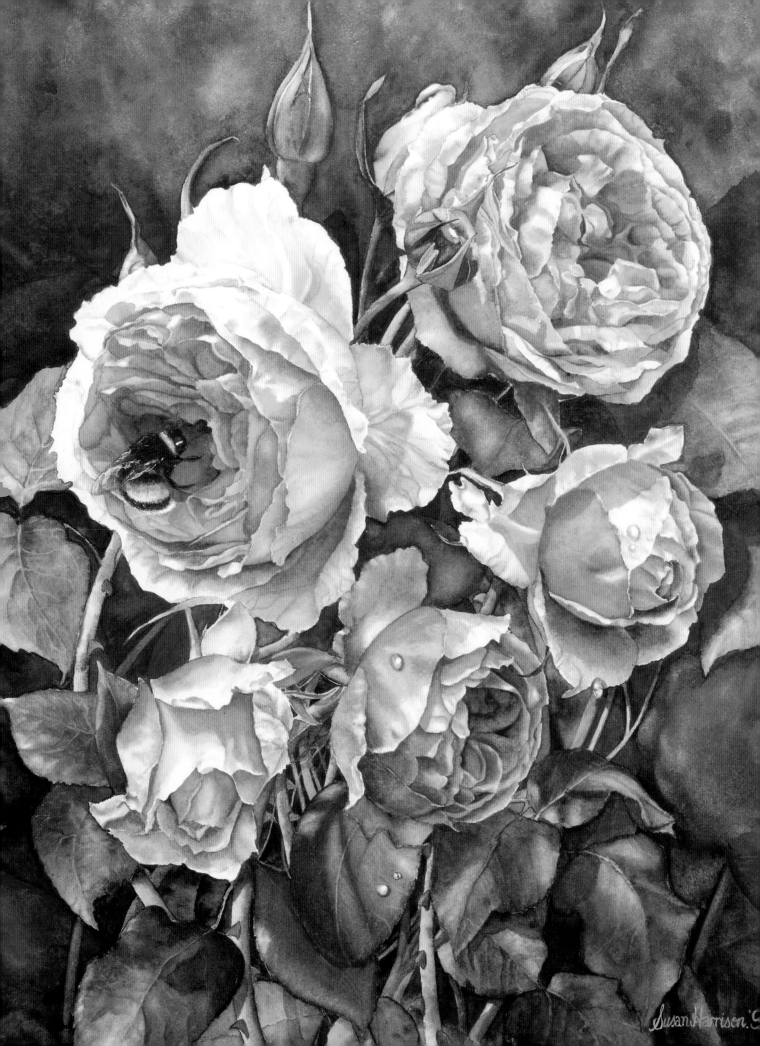

Susan Harrison '9

My main aim for this book is to have you painting with confidence. I endeavor to teach you not only to paint the subjects demonstrated but also that the methods and techniques shown can be adapted to any subject at all. I well remember the answers I needed when I first started painting, and now my students ask the same questions. This book will give you the solutions to these questions and many more.

Watercolor is a magical medium with an amazing versatility: We can achieve all the glorious, rich, warm darks that oil can produce, as well as the delicate and subtle translucency only watercolor can portray.

I was self-taught, and before I had read any books on watercolor, I was blissfully unaware I was breaking all the "rules." I had pushed past the preconceived boundaries and was achieving texture and depth with watercolor. I was painting "realism with a soul." My subjects had a "presence." I want to show you how to breathe life into your paintings, to see the subject evolving and becoming real before your eyes. With practice, it's possible to create a painting that can appear so lifelike even the artist, while still painting, will feel as if the subject is coming out of the paper to meet her!

We talk about perfection in nature, but in truth, there are few perfect compositions provided by nature. We artists have the good fortune to be able to rearrange and emphasize the "essence" of our subject into a composition that feels "just right." I rarely paint subjects that are perfect. I love to portray a spent flower or the occasional chewed leaf in my paintings. As you will see, these can give character, movement and life to the composition.

BUT I *LIKE* DETAIL!

Have you always been drawn—as I have— to paintings with detail but then told to avoid detail and "keep it loose"? Does something inside you scream, "But it's the detail that appeals to me most!" Those words challenged me to develop a style that incorporates looseness in the initial stages and fine, realistic rendering near the completion of the work. I refute the word *tight*. This conjures an image of a painting that has been worked and reworked, with little use of water, until it looks overworked and scratchy. The essence

> *"A thing of beauty is a joy for ever; its loveliness increases; it will never pass into nothingness. . . ."*
> —JOHN KEATS

of my style is a gentle, loose buildup of washes to bring depth and translucency to the work. Near the final stages, I add fine detail, then I soften the edges and deepen the shadows to bring the subject to "life." It's the presence that fine detail creates that draws me and moves me to feel part of the scene—to feel as if I can lean into the frame and smell the roses or touch the petals that are reminiscent of crushed silk or an antique crinoline gown.

Only yesterday I was amused by a fruit fly that was determined to land on my still life of apples—I couldn't get a more unbiased opinion of the trompe l'oeil effect I was after!

A FEW WORDS ON PRACTICE

There's a story about a golfer who hit a hole in one. His golfing partner remarked, "Wow, that was a lucky shot!" The golfer replied, "Funny thing about luck; the more I practice, the luckier I get!" This is true of painting also. Every time you put brush to paper you are learning. Each painting may not necessarily be the success you envisioned, but the lessons you will have learned on the way are invaluable. Don't measure the success of your work by the finished piece alone.

There are a number of artists whose work I really admire. Take a look at the work of those who move you and decide what it is that captures your interest. For me it is light and richness of color. When you're first starting out—or when you've decided to try a new style—try painting in the style of the artists who impress you. I have always been in awe of Rembrandt's paintings; trying to paint in his style taught me a great deal.

Of course, there comes a time when you are ready to move on and to evolve your own style. We so often feel we need confidence to try our own composition. I remember a time when I was having trouble with confidence and a friend said to me, "You don't need confidence; just do it!" At the time I thought it was one of those throwaway comments, but then I thought about it and realized he was right. It's "doing it" that brings confidence. Each time I feel tentative (and I still do from time to time), I remember his words and take up the challenge, and before I know it, I feel positive; I'm creating and loving it. So use the paintings of other artists to learn from and to gain inspiration, but don't use them as a crutch. And remember, keep pushing those boundaries!

ROSE "PARADE"
*watercolor on Arches 140-lb. (300 g/m²) hot-pressed watercolor paper,
20" × 14½" (51cm × 37cm), private collection*

Tools and Materials

When I first started painting in watercolor, I was like a sponge: always thirsty for any information. I would pour over every word in the multitude of books I had access to, and if I came across an artist's work I particularly liked, his palette and tools became my "flavor of the month." Now I look at my palette and sigh—I'm left with at least one hundred tubes of pigment, the majority of which I seldom use. After spending a great deal of time experimenting with many different brands and pigments, I have arrived at a list of supplies and colors that I feel is ideal to paint the very essence of florals as I wish to portray them.

The buzzing of a furry visitor to this garden led me to these pink pom-pom clusters of blooms. The Phthalo Blue/Green leaves were almost iridescent. The deep, dark richness in the background leads the eye and the imagination into the undergrowth—the perfect foil to enhance this superb bloom and buds.

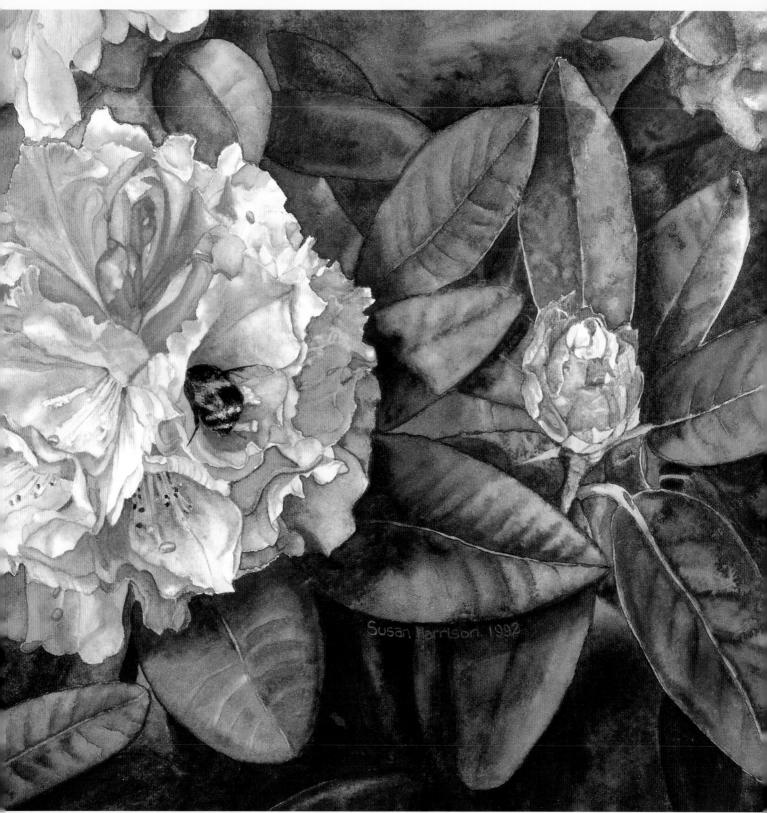

RHODODENDRON "COLLEGE PINK"
watercolor on Arches 140-lb. (300 g/m²) hot-pressed watercolor paper,
12″×18″ (30cm×46cm), private collection

Paints

Most colors can be used in floral work, but I have narrowed down my palette to just the few I find most successful. Before you rush out and buy the pigments I have chosen for "my palette," look at the colors you already have to ensure you aren't doubling up on similar hues. Substitute colors you already have where you can, and replace them with the suggested palette when you need to. If you are new to watercolor, by all means try my palette.

QUALITY AND BRAND

Never stint on the quality of paints; it is false economy. Artist's quality paints are much more lightfast and the pigment is denser, so they go farther than student- or economy-grade watercolors.

Although many brands have hues of similar names, you'll find the composition—and therefore the final color—can vary tremendously from one brand to the next. If a hue is listed in the following chapters without a specific brand name,

any of the brands will work equally well.

Not only the color but the performance of the pigment is important. I avoid oily colors as these tend to sit on the surface and lift readily when washes are applied. As my paintings take several weeks to complete, I need a paint that, once dry, will redisperse readily on my palette. My watercolors also need to be as lightfast as possible. A number of brands have recently released new ranges of lightfast colors.

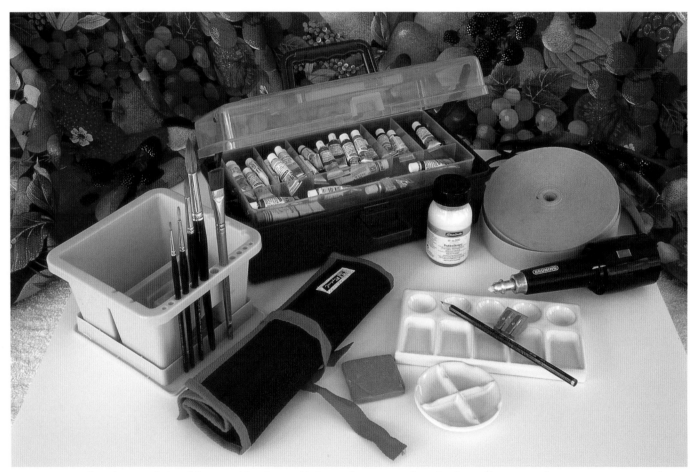

Here are my tools and materials: brush basin and brushes, tackle box with paints, masking fluid, stretching tape, electric eraser, mixing palettes, pencil, kneaded eraser, brush holder and Gator board.

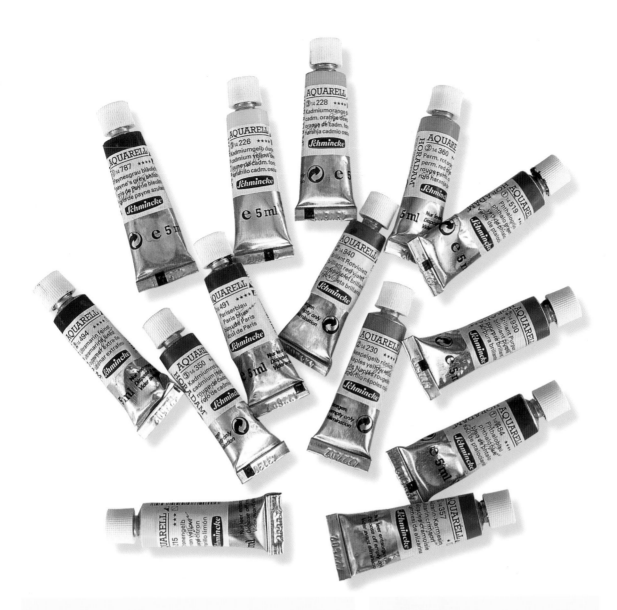

My "Can't Do Without" Palette

Schmincke Cadmium Red Deep

Schmincke Alizarin Crimson (Rose Madder Alizarin)

Schmincke Cadmium Orange Deep

Schmincke Indian Yellow

Schmincke Cadmium Yellow Deep

Schmincke Cadmium Yellow Light

Schmincke Phthalo Green

Schmincke Phthalo Blue

Schmincke Ultramarine Blue Finest

Schmincke Naples Yellow

Maimeriblu Dragon's Blood

Maimeriblu Sap Green

Winsor & Newton Transparent Yellow

Winsor & Newton Naples Yellow

Useful Additions to My Basic Palette

Schmincke Permanent Red Orange

Schmincke Titanium White

Schmincke Brilliant Purple

Schmincke Burnt Sienna

Schmincke Lemon Yellow

Schmincke Naples Yellow-Reddish

Schmincke Paris Blue

Schmincke Payne's Gray Bluish

Maimeriblu Primary Yellow

Winsor & Newton Aureolin

Winsor & Newton Permanent Rose

Winsor & Newton Burnt Sienna

Winsor & Newton Oxide Of Chromium

Brushes

I love to use da Vinci sable brushes. They keep a truly superb point. The smaller sizes aren't too expensive and, if taken care of, will last many years. Da Vinci synthetic brushes are also good and are cheaper. I like to use a no. 12 sable for larger areas. As it has a good point, it can cope with quite small areas very well also. In a typical painting I would use a no. 12, no. 4, no. 2 and no. 0 round sable brush. Look after them and you'll be well repaid with many years of service.

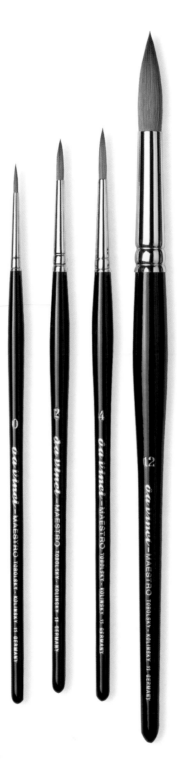

A flat synthetic brush comes in handy for lifting color. Occasionally I use this brush for softening edges. *Never* use your good brushes with masking fluid; keep old brushes for this purpose.

Other Materials

PALETTE

I have two favorite types of palettes. One is rectangular and one a small, round palette. Both are ceramic, as ceramic doesn't stain and, with care, will last a lifetime.

PAPER

My paper of choice is Arches hot-pressed 140 lbs. (300 g/m²). This is a velvety smooth paper that lends itself to detail and fine buildup of washes. Hot-pressed paper has a hard size (a coating applied to the paper surface during manufacture) that takes a little getting used to, but once mastered, it is difficult to beat.

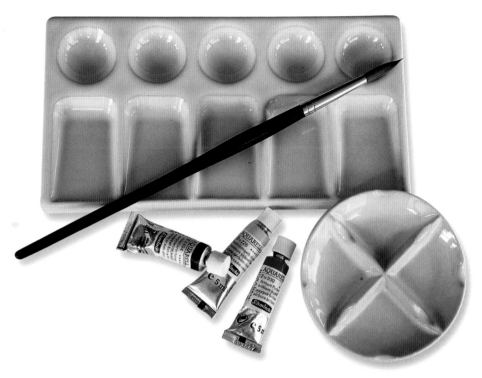

Clean Palette = Clean Colors

If you keep your palette clean, you won't be tempted to use pigments that have been contaminated by too many other hues.

MASKING FLUID

I have tried a number of masking fluids. Schmincke has the additional benefit of being suitable for use *over* an already painted passage without lifting the pigment when removed. I find that I use masking fluid less as time goes on. I occasionally still use it for preserving stamen when they are lighter than the local color of surrounding petals. This is done by painting the stamen, allowing them to dry, masking over them and then continuing to paint the petals once the masking fluid is dry.

PAINTING RAGS

I wouldn't be without a painting rag. I use it continuously for adjusting the amount of water in my brush by touching the brush on the rag. Soft cotton is best.

GATOR BOARD

This must be the find of the century! This board is lightweight, holds stretching tape firmly, won't warp and is easily washed when it gets a little grubby. Gator board is available in different widths and in a white and brown finish. I like 12mm white, which I cut to accommodate a half sheet of Arches paper, allowing at least one inch extra for tape. This board is readily available in art supply stores and through mail-order catalogs.

PAINT BOX

A new acquisition is my fishing tackle box. It is wonderful—why did I wait so long before I bought one? I used to be forever scratching around in my old plastic cake container, looking for the pigment I was after. Now I have sorted my hues into like-color groupings and have them at my fingertips in seconds.

ELECTRIC ERASER

I occasionally use an electric eraser if I have dropped a spot of paint where it's not supposed to be. I also use it for lifting out a highlight when I add a dewdrop as an afterthought. An expensive tool, but if it saves a painting, it's well worth it.

BLOTTING PAPER

I occasionally use blotting paper when I need to lift a passage, such as a branch, from a background. I fold the paper in half and dab the rounded, folded edge along the length of the area I wish to lift.

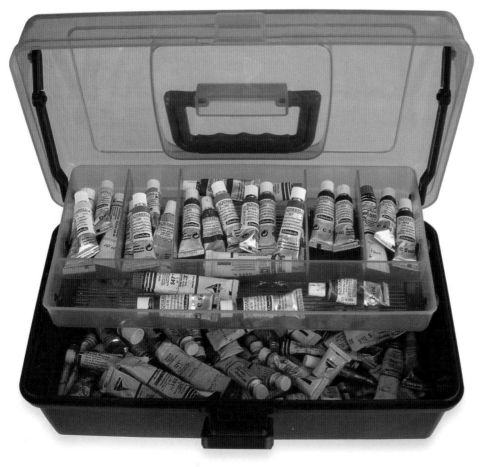

Stretching Your Paper

I always stretch my paper, regardless of paper weight. Prepare all the equipment you'll need before you begin: Gator board, stretching tape, scissors, a jar of clear water and paper towels. Before I start to use any water, I measure the pieces of tape I will need. I then put the tape away in a plastic bag (it's important to keep the glue away from water until you're ready to attach the tape). I soak my paper in the bath, submerged for five to ten minutes, then remove it from the water diagonally, allowing surplus water to run off. I place the paper on my Gator board and wet the measured pieces of tape by running them through the jar of clear water. I hold the tape alongside the edge of my paper, just above the surface; this helps to line the tape evenly with the paper. I then move the tape into the edge of the paper about half an inch, still holding it above the paper until I am happy with the placement. I then lay it in place, working my way around the sheet of paper until all four edges are covered. Finally, I dab a paper towel along the stretching tape to absorb the excess moisture. This speeds up the drying time and helps to flatten any air pockets hidden behind the tape.

Familiarize Yourself With Color Behaviors

To paint beautiful watercolors, no matter what the subject, one of the most important things you can do is to familiarize yourself with the pigments on your palette. Every pigment performs differently and has a character specific to itself. Just to confuse matters, each brand also has specific qualities that make it different from other brands, despite having the same name! One of the many advantages of watercolor is that we can use the various ways each pigment behaves to our benefit. Let's explore the different properties of the transparent, opaque and sedimentary pigments used in this book—you will see why I choose particular colors and avoid others.

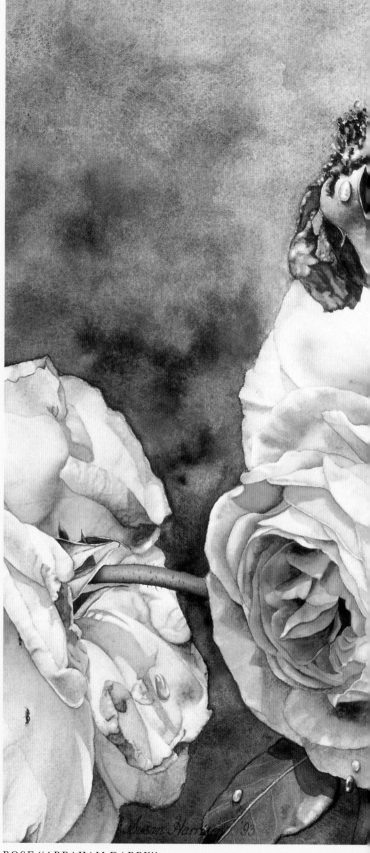

ROSE "ABRAHAM DARBY"
watercolor on Arches 140-lb. (300 g/m²) hot-pressed watercolor paper, 20¼"×27" (51cm×69cm), private collection

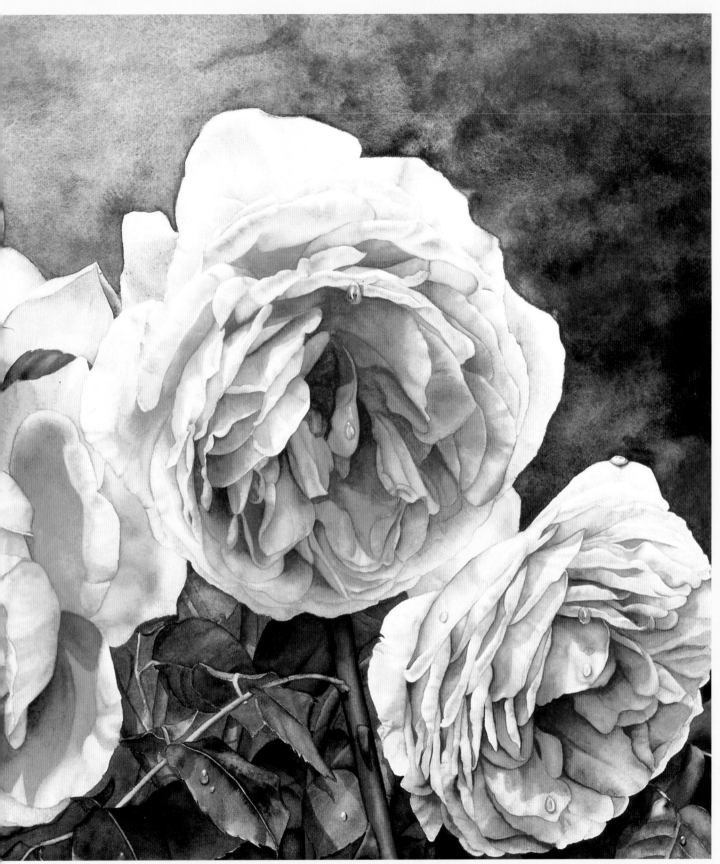

Nodding in the breeze, these four blooms were vibrant with color and their perfume was intoxicating. The luminous glow from the base of each petal adds a richness reminiscent of Chinese lanterns. There was a need for a fifth bloom to bring balance to the composition, so I simply turned one around to face the background. The half-turned rose, with its petals starting to curl with age, is the most moving. The strength of the spent flower completed the story, showing triumphant beauty in age. This painting was the winner of the inaugural New Zealand Gardener Art Award.

Clean, Rich Transparents

I particularly like to use transparent colors. I find it impossible to "muddy" transparent colors, as long as I'm mixing transparent with transparent. As you will see in the following chapters, I like to build up my color wash upon wash; transparent colors allow the previous washes to glow through and affect the final hue. Transparent colors also help to create depth in a painting; when used in backgrounds, they make the background seem to go on forever. While transparent colors add a luminosity to flowers and leaves, they aren't suitable for all textures.

MIXING TRANSPARENTS

I try to avoid mixing more than three pigments in any one wash. If I can, I paint in single-color washes, using the transparency of each pigment to its best advantage by allowing the previous washes to glow through and influence the following layers. When I require a clean, transparent feel in a painting, I use mixtures of transparent hues, occasionally with the addition of a touch of semitransparent pigment.

UNDERWASH WITH YELLOW FOR A FRESH GLOW

The easiest way to achieve a glowing color is to underwash your subject with transparent yellow. I use six different yellows for underwashing, depending on the subject I'm painting and the texture and luminosity I need. Four of these yellows are transparent colors, shown here. The other two are opaque yellows, shown on page 24.

An underwash of yellow also gives the subject "body" (notice how raw the non-underwashed color is in the top illustrations on the next page). Some subjects require a light pigment, so I use an initial wash that's barely noticeable, adding just enough yellow to avoid that "raw" look. Bear in mind that the depth of the yellow underwash can have an enormous effect on the final hue: A blue sky can look green if you use a deep yellow underwash. The lighter you require the finished wash, the lighter the yellow underwash needs to be.

Schmincke Indian Yellow—A clean, rich, warm yellow that can be thinned down to a lovely clear hue.

Winsor & Newton Aureolin—I think this yellow must be pretty close to a true primary yellow. It's neither warm nor cool and doesn't muddy if pushed either way when mixed with other hues. It does have a slight greenish tinge, more evident in the tube than when used. An excellent yellow that is very lightfast.

Maimeriblu Primary Yellow—A strong yellow, stronger and less green than Aureolin. Ideal for cool backgrounds.

Winsor & Newton Transparent Yellow—A lovely, clean, slightly cooler yellow. Less intense than Primary Yellow.

Pale Sap Green wash on white paper

Pale Sap Green wash over Indian Yellow underwash

Very pale Indian Yellow underwash

Deeper Sap Green wash on white paper

Deeper Sap Green wash over Indian Yellow underwash

Very pale Sap Green wash over Indian Yellow underwash

OTHER FAVORITE TRANSPARENTS

As I mentioned, a great deal of my work is done in transparent colors. Following are some of my particular favorites.

Schmincke Phthalo Blue

Schmincke Paris Blue
(I use this occasionally)

Schmincke Ultramarine Blue

Schmincke Ultramarine Blue Finest

Schmincke Phthalo Green

Schmincke Alizarin Crimson

Schmincke Madder Lake Deep

Burnt Sienna (this pigment is also sedimentary)

Maimeriblu Sap Green (has been described as semiopaque, but I find it to be a luscious green that gives clear washes)

Opaque Colors

Some petals and leaves are dense and require a totally different painting treatment. *Papaver orientale* shown on pages 28-29 is a prime example. The petals have a dull, velvetlike character that appears to absorb light rather than allow it to radiate through. This effect can be achieved with the use of opaque washes. When building up these washes, you'll need to be especially careful not to disturb the previous layers since opaque colors tend to sit on the paper surface. A bonus is that highlights can be lifted out easily and effectively.

Schmincke Cadmium Yellow Deep—This is a rich, warm, glowing opaque yellow, ideal for dense textures, such as the petals on pages 28-29.

ADDING WASHES OVER OPAQUE COLOR

The secrets to successful washes over opaque color are to always allow your work to dry completely between washes, and to lay in your clear water and pigment washes gently, with a minimum of brushstrokes. Allow the water to disperse the pigment for you wherever you can. This is a precarious practice, so care is needed.

ADDITIONAL YELLOWS FOR UNDERWASHES

As I mentioned on page 22, two of the six yellows I use for underwashes are opaque colors. These are Schmincke Naples Yellow and Winsor & Newton Naples Yellow. These pale yellows are almost body colors due to the amount of white in their contents. Be aware that these colors are two of the few that dry *darker* than they appear when wet. I use these opaques occasionally as underwashes, but only in very thin washes and only on light-colored objects to which I don't intend to add many successive washes. These colors give a little body to the surface without giving too much color. If you require more depth for your underwash, use one of the transparent yellows.

Schmincke Naples Yellow

Winsor & Newton Naples Yellow

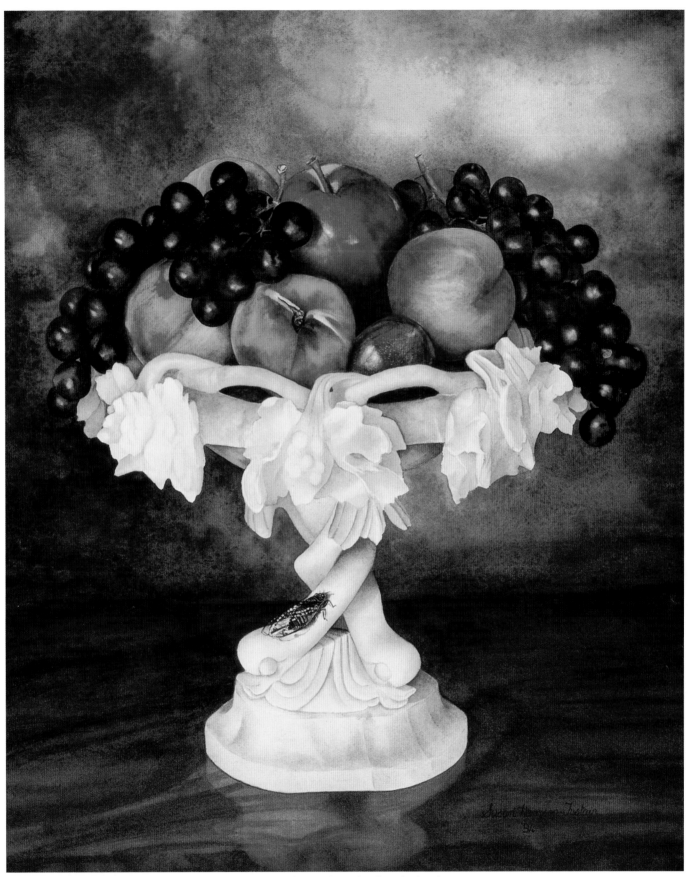

I also love to paint fruit. Notice how the thick, furry skin of a peach can be described with opaque colors, while a plum is painted in transparent colors. The background is painted in opaque colors, except the splash of Ultramarine Blue, which gives a break in the almost jewel-like background. Refer to chapter three for more details on backgrounds.

BOUNTIFUL HARVEST
watercolor on Arches 140-lb. (300 g/m²) hot-pressed watercolor paper, 18″ × 14¼″ (46cm × 36cm), private collection

Sedimentary Colors

These are pigments that have a granulation property. They include Yellow Ochre, Raw Umber, Burnt Umber, Raw Sienna, Burnt Sienna, Ultramarine Blue and Cerulean Blue. I find the characteristics of sedimentary colors vary considerably according to brand and manufacturer.

Yellow Ochre

Raw Umber

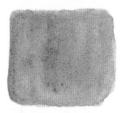

Raw Sienna

Burnt Sienna

Ultramarine Blue

Cerulean Blue

GRANULATED EFFECTS IN FLOWER PAINTINGS

You'll see wonderful granulated effects when you use any of the "earth colors," especially if you mix two sedimentary colors together. I don't use these colors a great deal, as the need for granulation is limited when painting flowers. However, backgrounds such as clay bricks, concrete walls or timber can make good use of this effect, as shown on the next page, so keep it in mind for such an occasion.

Mixing two sedimentary colors creates wonderful granulated effects.

BURNT SIENNA FOR INSTANT BRANCHES

The one earth color I use reasonably often is Burnt Sienna. It behaves in a most peculiar way when brushed with an almost dry brush into a wet underwash. It drops immediately onto the paper surface—pushing the water aside—leaving a wonderful suggestion of a branch that needs little alteration or fine-tuning. I use this method for branches that don't require much detail, such as those in a background. There is a catch: The amount of water you use in the underwash and mixed with the Burnt Sienna on the brush plays an important part in determining how successful your branch will be. You'll need to experiment to achieve the right combination of water and pigment. Winsor & Newton Burnt Sienna performs this trick extremely well.

This loose, flowing branch would be perfect in the background of a painting.

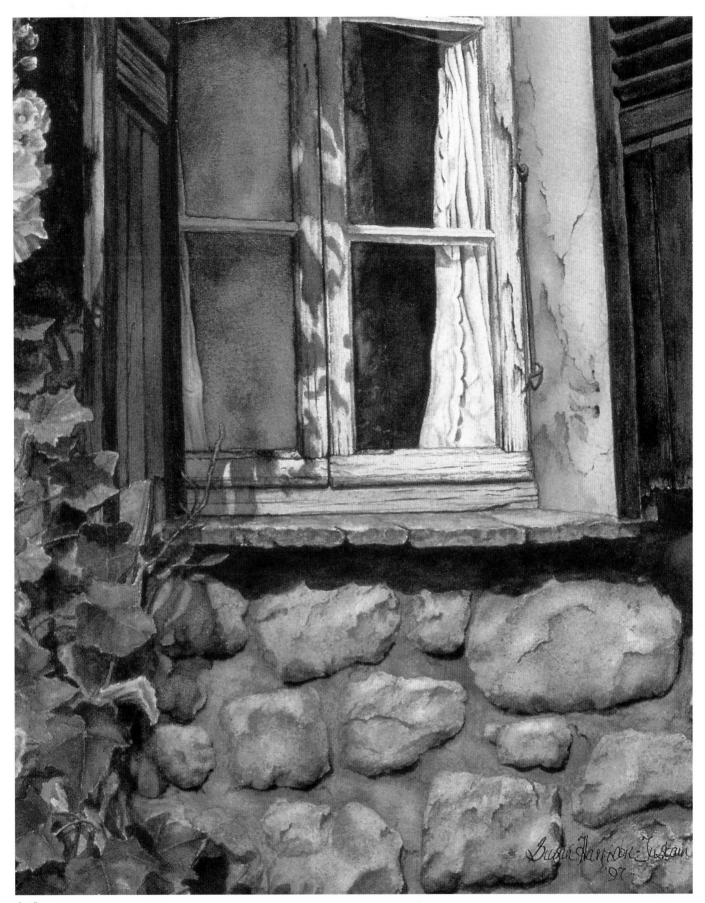

detail

FENÉTRE DE PROVENCE (WINDOW ON PROVENCE)

watercolor on Arches 140-lb. (300 g/m²) rough watercolor paper,
22″×15″ (56cm×38cm), private collection

Watercolor Techniques for Florals

There are many ways to paint lifelike florals. These suggestions show the methods I enjoy and find successful. A fine, transparent petal requires a different treatment than a dense, opaque petal. These methods have many applications. Learning to paint different floral textures and forms will give you the versatility to paint almost anything. Let's explore the different methods I use to portray the essence of the subject.

The strength of composition and the vibrancy of this painting are the main ingredients to the success of the work. I'll never forget coming across the bloom, almost tucked away amongst the weeds. The gentle folds and rich black spots compelled me to paint her. The pièce de résistance was the superb, mint-colored seedpod cheekily stealing some of the attention.

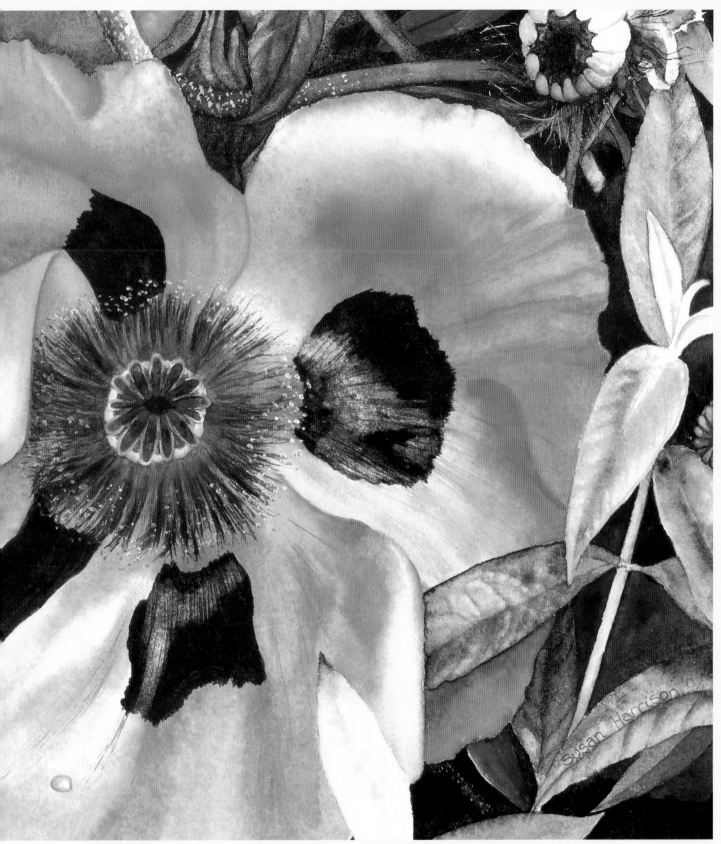

PAPAVER ORIENTALE
watercolor on Arches 140-lb. (300 g/m²) hot-pressed watercolor paper,
12½″ × 18″ (32cm × 46cm), private collection

Priming and Building Up Washes

The quintessence of my style is the gentle buildup of fine wash upon wash. You can achieve clear, clean, delicate lights through to rich, transparent darks using this method, giving your subject luminous substance and reality. I build my washes with a method I call *priming*, which helps me create a gentle buildup of color. The success of this method is mostly due to an initial application of clear water that is allowed to absorb into the paper. (Once this is absorbed, another wash of clear water is applied to the surface, into which the washes of color are added.) I use Arches 140-lb. (300 g/m²) hot-pressed paper, which has a hard, smooth surface, ideal for fine detail and gentle blending. As this paper's surface is hard, it's important to penetrate the "skin" and the middle layers with moisture. Priming these underlayers allows the liquid on the surface to stay wet and workable longer. You'll find you have more time to maneuver the pigment and that gentle blending will be easier.

To a degree, this method allows the initial applications of pigment to soak into the layers beneath the surface of the paper, enabling successive applications of washes without disturbing the initial washes. Priming also creates softly flared edges, soft creases or veins, gentle merging of shadow edge and local color and so on. This is in contrast to painting one layer wet-on-wet or wet-on-dry, which doesn't allow the pigment to penetrate very deeply, thus leaving more pigment on the surface that may be disturbed during subsequent washes.

Priming is used particularly in the initial stages of a painting. As the work progresses and the density of color reaches the richness I desire, I then need more control. This is achieved by gradually reducing the amount of moisture. There are times when the final application of pigment is drybrushed on (see page 32).

My Priming Method

STEP 1. Wet the entire area to be painted. Now allow the paper to absorb the water just until the sheen has gone from the surface.

STEP 2. Moisten the paper again. The amount of water used at this stage depends on the effect you are after. Your paper is now primed and ready for your wash of pigment.

The secret to building up washes is knowing how much water to use. Following are the terms I use to describe the amount of water needed for each effect.

Damp
This is when the paper is close to dry—the water has been absorbed by the paper and allowed to evaporate until the paper is almost dry to the touch.

Moist
I use this term when the water has soaked into the paper but still leaves a slight sheen on the surface (tilt your paper toward the light to see this more clearly).

Wet
Just as it sounds, this term indicates there is a reasonable amount of water still sitting on the surface of the paper. The water can be moved around by tilting the paper. Notice the hard edges. The more water used, the more apparent the hard edge. The pigment will appear to be pulled to the edge of this wet area.

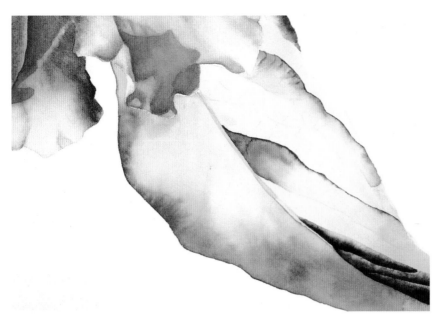

BUILDING UP WASHES

1 I laid down initial washes of color using my priming method. The gentle blending achieved with priming gives the leaf a wonderful softness.

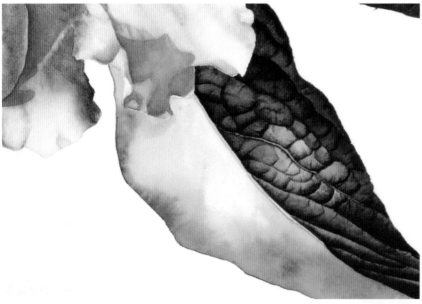

2 I section off areas and work these slowly, building up the washes and allowing the pigment to flare into the lighter areas, giving a soft highlight.

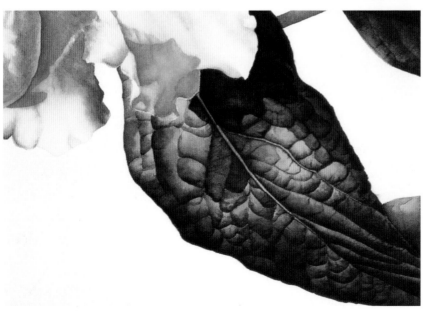

3 This leaf was completed using less water in the final stages, giving more depth to specific areas where required. Some areas were painted using a dry-brush method after the last pigmented wash was laid in and dry. The final stage was executed only after the paper was *completely* dry. (Allow the sun to "bake" the pigment if possible, or you can wait until the next day to complete this final step.) Now lay a wash of clear water *very* gently over the entire leaf. This will gently merge the demarcation lines between the segments and give a naturalness to the undulating surface.

WET-ON-WET

This method produces gentle blending, flared colors and soft edges. I like to use this method in the early stages of paintings and for backgrounds. It is produced by picking up a good amount of water with your pigment and applying it to a wet surface.

WET-ON-DRY

This method results in hard edges (which I usually soften) as you are applying the wash to dry paper. It's a quicker method I use when I need more control over the pigment. You need a good grasp on how much water is required in your brush, as too little water will result in a scrubbed appearance.

DRYBRUSH

This method is excellent for fine-tuning and finishing line detail. With drybrush you have total control as the brushstrokes stay where they are put. Load your brush with pigment, then touch it to a rag to remove most of the moisture. Your brush should be barely damp. I finish most paintings with drybrush. This can produce a scratchy appearance if overdone.

Mixing Rich, Velvety Blacks

I *never* use premixed tube black. A rich, deep, velvety black can be achieved with a mix of Alizarin Crimson and Phthalo Green; sometimes I also add Phthalo Blue. Using a mix to create a dark gives you the added benefit of pushing the dark from warm to cool by simply adjusting the amount of either pigment (Alizarin Crimson or Phthalo Green) to favor one more than the other. This is especially useful when using this mix in a background. For example, when you want a dark to surround a green leaf, use more Alizarin in the mix to give contrast (red is the complementary color of green). When the dark is surrounding a flower, especially if the flower is of a pink or reddish hue, push the black more toward Phthalo Green. Not only are these hues opposite on the color wheel, but they also use the warm against cool theory. You'll see your lighter colored subjects dance before your eyes!

Papaver orientale on pages 28-29 is a wonderful example of how rich and dark these mixed blacks can appear. Notice how the mixed black has a velvety appearance when a number of fine layers are built up. I have lifted some pigment to create natural-looking highlights.

Tube black

Alizarin Crimson/Phthalo Green mix, favoring green

Alizarin Crimson/Phthalo Green/Phthalo Blue mix, favoring blue

Alizarin Crimson/Phthalo Green/Phthalo Blue, favoring red

Mixing Rich, Transparent Darks

I love luminous, transparent darks. They are particularly useful for backgrounds. You may have noticed how I often have a dark passage at the bottom of my painting, sometimes extending up and past the center of the paper. There are many reasons why this adds to the success of a painting: It anchors and gives weight to a floral scene; it looks natural as the foliage is generally denser at the base of the plant; and it provides a wonderful foil for foreground leaves and flowers, pushing blooms forward to add to the three-dimensional appearance. Transparent darks give the illusion of depth.

When painting darks I lay in a rich, transparent wash of a yellow, such as Aureolin, Indian Yellow, Transparent Yellow or occasionally Primary Yellow. This gives a glowing appearance to the translucent dark I'm trying to achieve. This depth of yellow is needed to make the finished dark glow. Over the yellow underwash I lay in successive washes of transparent colors. I particularly like Alizarin Crimson, Phthalo Blue and Phthalo Green. These are among the strongest staining pigments. They can either be mixed on the palette or by laying one color over another. They will give a powerful, transparent dark unmatched by any tube color.

Transparent yellow underwash

Transparent dark over yellow underwash

Same mix as left without the yellow underwash

Boosting a Limited Palette

Although it is generally accepted that it's best to limit your palette to just a few colors, I occasionally find I need to push a color darker than is possible with the colors I have on my palette. This is because the colors are all "common"—they are varying mixtures of the same hues used throughout the painting. The introduction of a new hue will often give a boost to the dark you're trying to achieve. Look at the darks inside the trumpets of the two center white daffodils on page 103. Keep in mind the "warm against cool" effect, as this will also give punch to your dark.

at right
ROSE "GRAHAM THOMAS"
watercolor on Arches 140-lb. (300 g/m²) hot-pressed watercolor paper, 22" × 18½" (56cm × 47cm), private collection

I wanted an area at the base of this painting to push the foliage and lower blooms forward. You can see varying degrees of dark—these are achieved with a mix of Phthalo Green and Alizarin Crimson over an underwash of Transparent Yellow. I still needed to go darker to give interest and depth, so I chose to increase the Alizarin Crimson slightly and add Phthalo Blue. This gave the dark area another dimension.

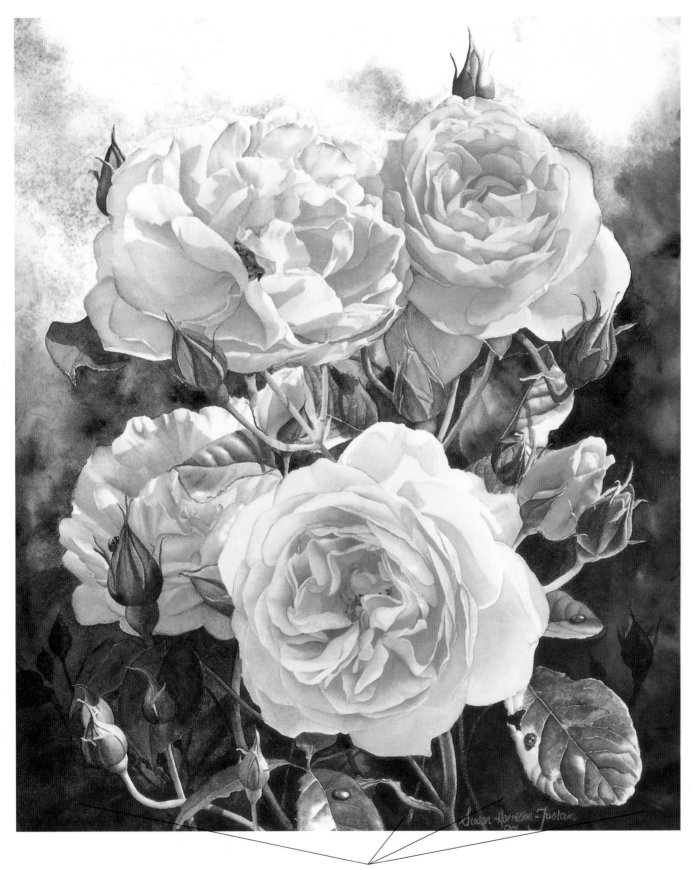

Luminous, transparent darks

Painting Delicate Lights

Although it's hard to imagine, even the delicate, light shades in my paintings require several washes. Obviously the color is less dense (more water, less pigment) than for the darker shades. I love to mold the form of the petal with extremely fine washes, building up grad-ually until the petal looks as if it is presenting itself to you. Delicate lights can be fun to capture, especially if there are creases, ruffles or folds that throw shadows and create a distinctive feature, revealing the character of the bloom.

There are several fine washes of color used to describe the form of the roses below. Using my priming method, I drop in lightly pigmented washes and allow the moisture to disperse the hue rather than using brushstrokes.

It takes several fine washes to paint even the lightest areas

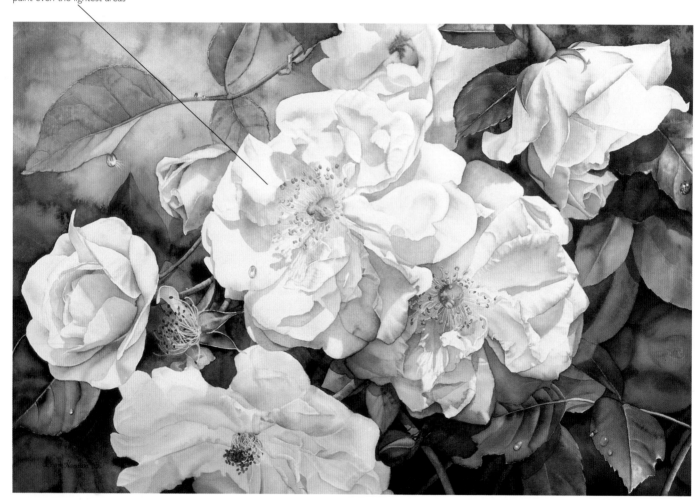

ROSE "ADÉLAIDE D'ORLÉANS 2"
watercolor on Arches 140-lb. (300 g/m²) hot-pressed watercolor paper, 18½" × 27½" (47cm × 70cm), collection of the artist

Background Affects Flower Color

If you choose to complete the flowers and leaves before the background, as I do, more often than not the flower color will need strengthening once you add the background color. It is amazing how a flower that seemed richly colored against a white background can seem drained and insipid once it is surrounded by background pigment.

Brights That Dance on the Paper

The secret to vibrant brights is to keep colors clean and fresh. Use tube colors unmixed, or mix pigments that give a clean hue. I'd like to touch lightly on color theory here, without going into too much depth.

EQUAL TEMPERATURES FOR CLEAN MIXES

To keep your colors fresh and clean when mixing, keep the position of the hue on the color wheel in mind—mix warm yellows with warm reds, cool greens with cool yellows, etc. A good example of a clean orange mix is made from Cadmium Yellow and Cadmium Red. These are both warm colors and are close to each other on the color wheel. In contrast, Cadmium Yellow mixed with Alizarin Crimson (a cooler blue-red) will give a muted orange that will be much less vibrant and will not "carry" as well from a distance.

COMPLEMENTARY MIXES FOR MUTED COLORS

When mixed, complementary colors (red/green, blue/orange and yellow/purple) cancel each other out, producing a grayed hue. This is not to say you can't mix these colors. Shadows are more realistic if at least some of the local color's complementary is used in the shadow mix. In addition, paintings are more natural if there are some bright colors juxtaposed with some muted shades. If all our mixes gave bright, vibrant colors, they would fight against each other for dominance so that no one feature stood out. I like my brights to be supported and enhanced with the use of many hues, including these muted "mouse" colors. The rich and lively colors of the apples on page 38 are enhanced by the muted mouse-colored background.

Cadmium Yellow Deep + Cadmium Red Deep

Cadmium Yellow Deep + Alizarin Crimson

red/green

blue/orange

yellow/purple

Alizarin Crimson is a blue-red, quite close to purple on the color wheel. When mixed with Aureolin—a greenish yellow closer to green on the color wheel—the complementary tendencies come into play, that is, purple with yellow, green with red. This results in a slightly grayed orange.

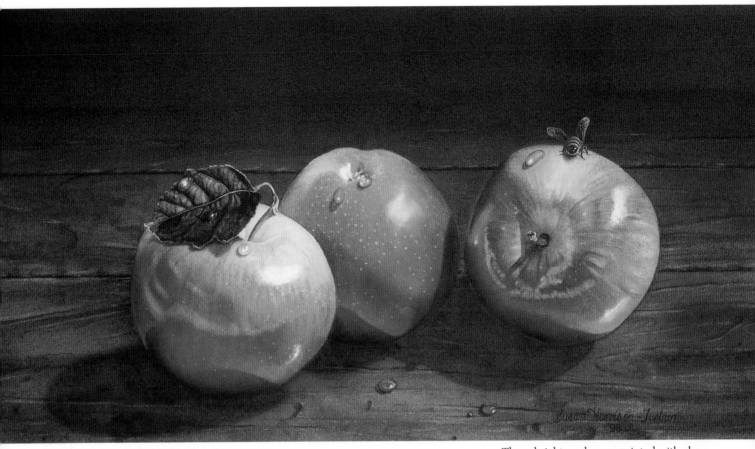

POMMES SUR BOIS (APPLES ON WOOD)
watercolor on Arches 140-lb. (300 g/m²) hot-pressed watercolor paper,
8″×17″ (20cm×43cm), private collection

These bright apples are painted with clean mixes made from colors close to each other on the color wheel. When set against a muted background, the colors seem to dance on the paper.

Blending

Watercolor lends itself to gentle blending. Another name I use for blending is *flaring*. My priming method is excellent for multilayered blending. To achieve a successful blend of color, you need control and an understanding of the amount of water needed to disperse the pigment to just the right degree. Familiarize yourself with the reactions you get from varying pigments when mixed with different amounts of water. (See page 30 on priming for more information on how much water to use.)

Practice Makes Perfect

Always keep a scrap piece of watercolor paper next to your painting to practice a new technique on before applying it to your painting.

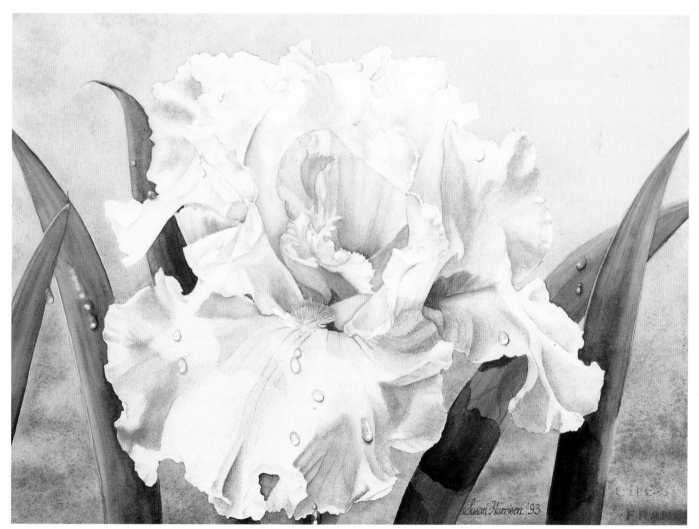

IRIS "MEMPHIS DELIGHT"
watercolor on Arches 140-lb. (300 g/m²) hot-pressed watercolor paper, 13½" × 19" (34cm × 48cm), private collection

In this painting you'll notice how the form of the petals is suggested with delicate blending of hue and tone along with a gentle transition from warm to cool and from one color to the next as the petal unfolds and presents itself. The soft folds are formed by blending many fine washes, accenting the depth in areas where there was shade and richer blushes of color. The ruffles at the edge of the petals are reminiscent of a Victorian gown and are so indicative of this beautiful iris.

Softening Edges

I seem to have an aversion to sharp or hard edges—this is reflected in my painting. I tend to soften many of the edges, including those of shadows. Although sharp-edged shadows are indicative of hot, sunny days, I prefer to soften them slightly, reducing the jarring effect as the eye moves from the local color to the shadow color. Of the number of ways to soften edges, there are two methods I use with equal frequency: priming and damp brush.

PRIMING METHOD OF SOFTENING EDGES

Once again my priming method comes to the fore, but with a slight twist: Wet the area you wish to work on, allowing the water to extend past the edge you need to soften. Let this wash be absorbed until it is almost dry (slightly cool to the touch). Now redampen only the area you wish to be pigmented. Gently stroke your paint-loaded brush along the edge you want to remain soft. As the paper is slightly damp past this edge, the pigmented wash will gently blend into the damp area, giving a soft, muted margin.

DAMP BRUSH METHOD OF SOFTENING EDGES

As soon as a painted area has *only just* absorbed the moisture, wet a brush with clear water, squeeze it dry and run it along the painted edge—half on the painted area and half off. The right-hand edge is softly blended with the white unpainted background while the left-hand edge stays hard and unblended.

The amount of moisture on your brush is crucial to the success of this technique. Too much water left on the brush will cause the already painted area of the paper to absorb the moisture from the brush, creating a "bloom effect" in the partially dry pigment. This is a *capillary reaction*. To understand why the degree of moisture is so important, you should understand this effect.

Priming method

Damp brush method

Capillary Reaction

Imagine the paper and brush are sponges.

- A dry sponge will soak up water from a wet sponge when the two are placed together.
- Two sponges that have the same degree of wetness will, when placed together, retain their original degree of moisture. No tension is created between them.
- A damp sponge will absorb moisture from a wet sponge until both sponges reach a similar level of moisture (at this stage the tension has subsided).

This lesson applies to all watercolor work, including softening edges, gentle blending and flaring color. Think about the sponge, how much water you're using and what effect you want to achieve. After a while it will become second nature.

This is a demonstration of capillary reaction. The sienna area is drier than the blue area. A tension is created, causing a pull of moisture from the wetter area (blue) to the drier area (sienna), which is essentially acting as a sponge. Blue pigment flows into the sienna, causing a "bloom."

Here both circles contain the same degree of moisture, causing no tension and resulting in little crossover of pigment.

Lost and Found Edges

When you look at a subject, analyze it. Take note where some edges are sharp or well defined and some edges are soft and blend into the background, or into other petals, leaves, etc. The sharp or well-defined edges—called *found* edges—are the easiest to achieve. To create soft, or *lost*, edges, keep the capillary reaction of paper in mind when you build up your layers of color, gently letting the pigment flare into the background at each wash stage, creating a soft edge.

The painting at the right has a deep, translucent background with luminous shadows cast by other petals and leaves outside the picture area. I built up the background, allowing the shadows to blend gently over the leaves and giving a soft, undefined edge—a lost edge. You can create a wonderful illusion of depth and mystery using this approach.

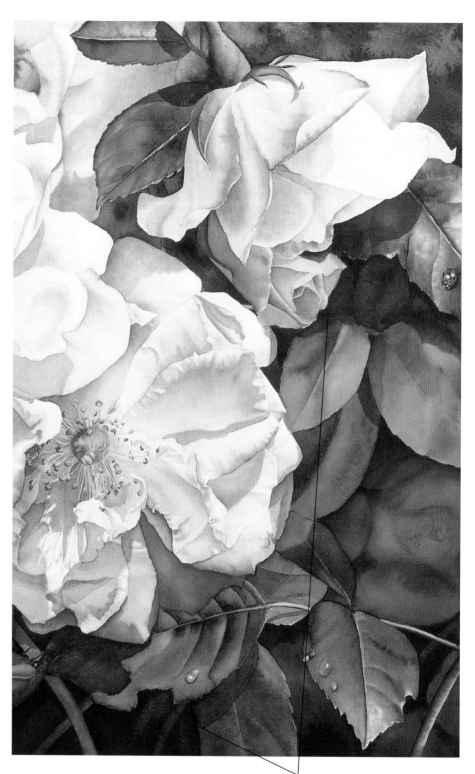

Lost and found edges pull the leaf into the background, giving dimension to the painting.

White-on-White

I adore white-on-white, the epitome of "simplicity has force." To achieve a convincing white-on-white study, you need to use plenty of observation skills. Look closely at a white flower and you'll see that the "white" petals actually contain a myriad of colors. Use these colors in your painting to describe the white petals. As with most palettes, I use three basic colors: red, yellow and blue. Most often I choose Alizarin Crimson; one of the transparent yellows, such as Indian Yellow; and Phthalo or Ultramarine Blue Finest. By careful observation you will see the difference between warm and cool areas and be able to use a combination of these colors to describe the hues you see. Teach yourself to see the colors that make up each flower. You'll be amazed how quickly you can become an excellent observer.

In this study the "white" of the daffodil stands proud of the white background. Look closely at the colors I've used to portray the creases and folds—some warm, some cool. I've also used reflected color from the trumpet. The shadows allow some petals to recede while the sunlit petals appear farther forward.

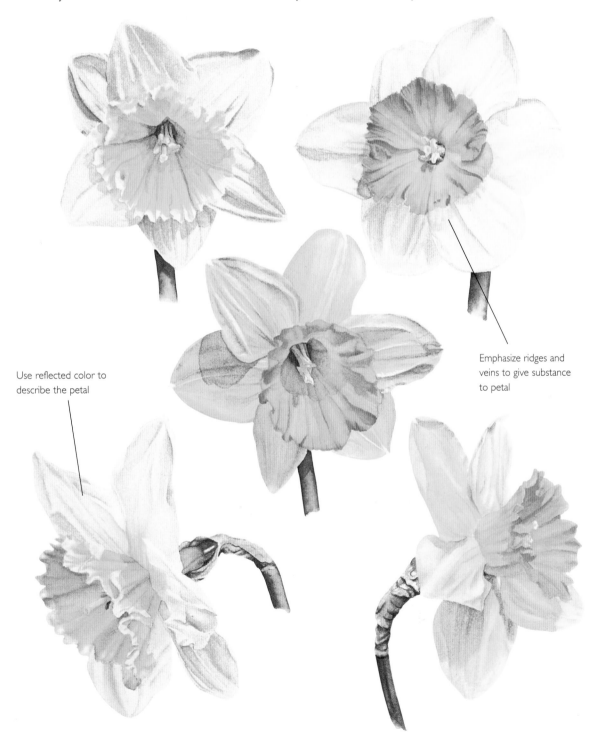

Use reflected color to describe the petal

Emphasize ridges and veins to give substance to petal

Gentle Blending of Backgrounds

The secret to a blended background is simply knowing the amount of water to use. My backgrounds are painted very wet-in-wet. I like the pigment to flare and merge on top of previously dried layers, allowing a gentle, blurred blend that gives the impression of distance. Florals tend to look most effective when a transparent background is used. This gives the impression of depth—of space and mystery behind the foreground blooms. Again, I use my faithful formula of an underwash of transparent yellow. (See pages 22 and 24 for the breakdown of yellows I prefer and why.)

The difficulty arises when the background area you wish to paint is rather large and difficult to keep wet. By the time you've wet the main background area and worked your way around the blooms and leaves, the water is often absorbed in the area where you started. The following method allows you to blend your background in smaller parts.

Primed
nonpigmented
area

Demarcation
line

1 Wash the entire background area with clean water. Now divide the space into separate areas and wet one space at a time, leaving a margin of clear water. The water must extend well past the planned pigment demarcation line. Once you've finished adding pigment to this area, move to the other side of the page.

2 Paint the other areas of background using the same method. When both areas are completely dry, work the area in between, flaring the water over the soft blends previously created. Build up depth by adding additional washes, using the same process and allowing the washes to dry between layers.

Drop in pigment up to demarcation line

Wet with clear water

Opaque Backgrounds

Although my preference is for transparent backgrounds, occasionally an opaque background is needed. Rich, jewel-like backgrounds can enhance and emphasize transparent foreground subjects. To create an opaque background, I prime the entire background area then lay in an underwash of Cadmium Yellow Deep, avoiding the lightest areas and areas of blue. I then add a subsequent wash of opaque pigments, such as Cadmium Red Deep, Cadmium Orange Deep, Burnt Sienna and Naples Yellow, and just a few transparent pigments, such as Sap Green, Phthalo Blue, Ultramarine Blue Finest and Alizarin Crimson. I apply colors quite thickly to alleviate the necessity of further layers—these pigments tend to sit on the paper surface and are readily disturbed by subsequent washes. This method produces a jewel-like background. Study the lustrous opaque background in *Bountiful Harvest*, shown on page 25. It's easy to create using the following techniques.

1 On a primed background, drop in opaque colors along with some transparent pigments of your choice. If this is going to be your last layer of color, you could swirl in Naples Yellow to give the painting a misty look. (When applied thickly, as in this case, Naples Yellow will muddy subsequent washes, so include it in the last wash only.) Allow to dry. You may wish to leave your background rich and vibrant, but if you'd prefer it darker, follow the next step.

2 As opaque pigment has a habit of lifting, use gentle brushstrokes when deepening the background color. Wet the entire background again. Now add a wash of Ultramarine Blue Finest and Alizarin Crimson. If this is too dull, an alternative would be Alizarin Crimson and Phthalo Blue. See how the background glows!

Luminous Shadows

On first glance, a shadow could look gray; take time to really see which colors make up the shadows. I often emphasize the colors I see within the shadows. This allows the normally dull areas to dance with color and makes the painting seem alive.

Hard shadow edges give a harshly sunlit effect. I prefer to keep them soft, as described on page 40. I almost always paint the area in shadow with local color initially, just as if it were without shadow. I then mix some local color with its complementary and a touch of staining transparent pigment (my choice of hue depends on the color I'm trying to achieve) and drop this shadow mix into an area that has been primed and re-wet. Allow the water to disperse the pigment naturally. I like to use transparent colors, which allow the local color to glow through.

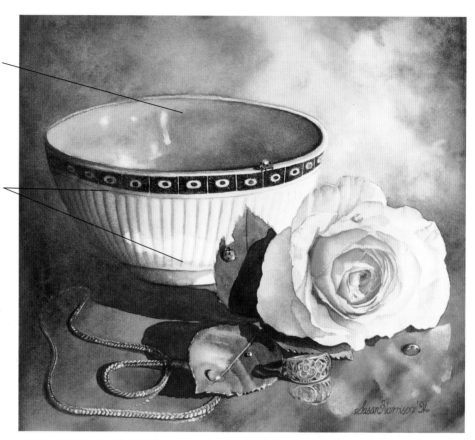

Muted colors within shadows create realism

Lively, warm, glowing shadows suggest substance and form

LUMINOUS TAPESTRY
watercolor on Arches 140-lb. (300 g/m²) hot-pressed watercolor paper, 5½" × 7" (14cm × 18cm), private collection

The lively warmth of its shadow gives the bowl substance and form. There are many features in this painting, but for me, it's the glowing shadows that portray the mood of the piece.

Heightening Transparency

A shadow will become even more transparent if you show a vein, rib or crease running through and beyond the shadow boundaries, as in this detail from *Daisy A Day*, shown on page 122.

Modeling Form

To demonstrate the techniques for modeling form, I've painted a cream can I found in a lovely cottage garden. The same principles used to paint this container can be applied to petals, leaves or any other subject you paint. Three-dimensional form can be created using one or all of these three elements: warm against cool, light against dark and sometimes the use of complementaries. Another element that helps describe contour is line, but it doesn't necessarily have to be evident. The cream can is sidelit, ideal for giving the impression of rounded form. This lighting helps demonstrate how our three key elements give shape to a flat piece of paper.

I have kept one side of the can light and warm in hue while the shadow side is described with dark, cool colors. Notice how I've enriched the rust color as the can moves away from the light. The theory behind this is simple: Sunlit areas are light, as color is washed out where the sun strikes. As the area moves away from the light, the color becomes richer. I extend this richness around and under the shadowed area. Last, I add the shadow and softly merge at the edge to avoid harsh lines.

The dents are molded using the same principles on a smaller scale. Lines also have added to the illusion of shape. Notice how the leaf shadows in the lid add to the impression of the lid shape.

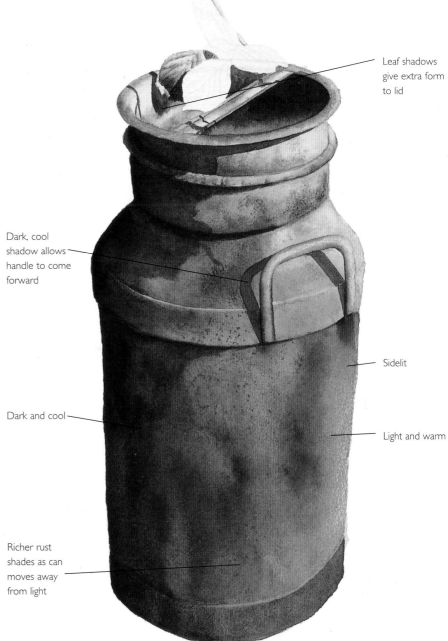

Leaf shadows give extra form to lid

Dark, cool shadow allows handle to come forward

Sidelit

Dark and cool

Light and warm

Richer rust shades as can moves away from light

Shadows on Rust

An ideal shadow color for use on rust is a mix of Maimeriblu Dragon's Blood and Ultramarine Blue Finest. One of the properties of Ultramarine Blue Finest is the dull, almost powdery finish it leaves when used with any depth; this works to great effect on the dull surface of this rusty cream can. It's important to keep this in mind when using Ultramarine Blue Finest as there are some applications where this effect would be undesirable.

Creating Dimension With Value

Value simply means the lightness or darkness of a color. I think of value as the construction blocks of the painting. Blocks of varying depths build the painting and give it dimension. A light object will appear closer than a dark object. If something is sidelit, the lighter side is closer to the light source, describing its form as it becomes darker and moves away from the light. My pre-sketches are value sketches, giving me an overview of the strength of my composition.

I love to use a full scale of value as this emphasizes the form of a three-dimensional subject. Without the use of a wide value scale, paintings can often appear flat and very "painted." I like my work to have a "presence," achieved by using value.

A Quick Word on the Push-Pull of Color

Have you ever noticed how distant hills have a blue or purple appearance? This *aerial perspective* is an example of the push-pull of color in nature. In reality, if you walked those hills you'd probably find them covered in green grass and foliage. The greater the distance between the hills and the viewer, the less warmth is required when re-creating them in a painting. Warm colors appear closer while cool colors recede. Red, being a very warm color, is the first to be diffused. Although I don't like "rules," as I feel they can stifle experimentation, I do avoid using strong warm hues in backgrounds when I want to create the appearance of great distance. I like to keep my foreground relatively warm in color, while I allow the background to recede by using cooler hues. Warm and cool colors placed alongside each other will appear to be on different focal planes.

If you painted a foreground garden border with soft, warm colors then stuck a bright red or bright yellow flower in the background, you'd find the composition would be less than convincing—the red or yellow would be dominant and appear closer than the foreground. A muted red or yellow would be less imposing. White works the opposite way: Cool whites come forward while warm whites recede.

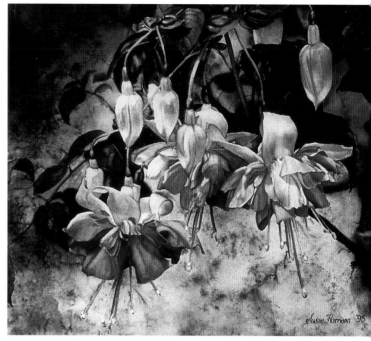

I've used a full range of tonal values to describe this fuchsia. This method worked particularly well with this piece—the unopened buds appear to fall so far forward you could almost pop them open!

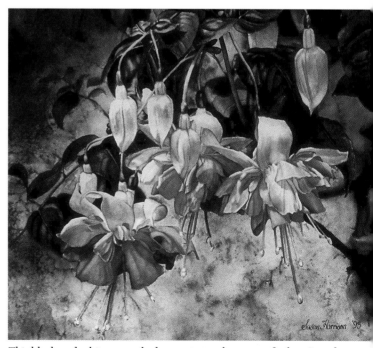

This black-and-white example demonstrates the range of values I used.

Making Flowers Glow With Light

L ight gives life and realism to a painting. When I critique a painting for a student who is having a spot of trouble achieving a three-dimensional appearance, nine times out of ten the problem is lack of sunlight. *Magnolia officinalis* on pages 52-53 exudes light and vitality— the flower dances on the page because it is bathed in sunlight. I can't emphasize the importance of light enough.

Ask yourself before starting a new painting, how much light do I wish to illuminate the subject? It doesn't have to be a great deal. Sometimes dappled light, or even a shaft of light, as in *Recolte de Provence*, can be just as effective. When you plan your composition, choose foreground subjects that are bathed in sunlight and you'll find that bringing them to life is much easier. Continually remind yourself to keep the painting alive with sunlight as the painting progresses.

Shadows

Keep in mind that along with sunlight there is shadow. Keep your shadow edges soft, unless you want to portray a searing, hot, sunny day. I find gentleness appealing, and soft shadows will add to this character. (See page 40 for more on creating soft edges.) The stronger the shadow, the brighter and more dramatic the sunlight on the highlighted areas will appear.

In this painting, the rich, deep shadows create a foil for the single shaft of light, making the highlight areas seem to radiate with intensity.

RÉCOLTE DE PROVENCE (HARVEST OF PROVENCE)
watercolor on Arches 140-lb. (300 g/m²) hot-pressed watercolor paper, 18" × 8½" (46cm × 22cm), private collection

Suggested Detail

Rather than spelling everything out for the viewer, added depth can be achieved by the mere suggestion of detail. I often use suggested detail in the background of a painting and occasionally in a less dominant area in the foreground. If a painting has equal detail on every subject, the mystery is taken from the piece. I like to have one main subject, dominant and rich with detail, supported by other less detailed subjects. Generally, if I'm painting a number of blooms in the foreground, the difference is slight but becomes more obvious the farther each subject recedes.

Fine-Tuning

I use this term to describe a variety of adjustments I make to the all-but-finished painting. Working section by section can sometimes leave hard demarcation lines. This is undesirable, particularly on leaves and flowers. Using mainly transparent colors and gentle brushwork, you can gently blend and unite the petals and at the same time soften the demarcation lines. This method is less suitable if opaque colors or very sedimentary colors have been used.

When I've finished each flower, I brush clear water over the entire bloom, thus lifting and redispersing a small amount of pigment. This makes the bloom look whole rather than a composition of individual petals.

Fine-tuning is also darkening or lifting color to accentuate shading or highlights. At this stage I often merge shadows over petals, creating a lost and found edge that gives the impression of depth. This is done by wetting the shadow and petal areas, allowing a margin on the petal for soft blending. I then drop in shadow color in the shadowed area, allowing the pigment to migrate up onto the petal. It's at this stage that I often add a ladybug or a number of dewdrops to give added interest and life to the composition. (See chapter five for step-by-step instructions on creating these lifelike details.) This is also a good time to add fine dry-brush details, particularly if lines, creases and veins need darkening.

Floral Textures
Step by Step

I love to portray the "feel" or texture of my subjects. It's the translucency or opaqueness, the delicate or rubberlike feel that gives each flower its distinctive character and sets it apart from other varieties. With other mediums, texture can be created through the use of thick, gooey paint or apparent brushstrokes. The challenge with watercolor is to create the *illusion* of texture, giving viewers a sense of the flower's feel. I gain a lot of pleasure by creating the illusion of so many different surfaces. The following short demonstrations will teach you to create some of the most common floral textures.

MAGNOLIA OFFICINALIS
watercolor on Arches 140-lb. (300 g/m²) hot-pressed watercolor paper,
15½" × 19" (39cm × 48cm), private collection

The thick, rubberlike texture of these magnolia petals was a challenge I couldn't resist. A rare magnolia in New Zealand, it is notable for its deeper hue on the outside of the petal and by the almost tropical appearance of the huge leaves—a delight to paint as they supported the bloom magnificently.

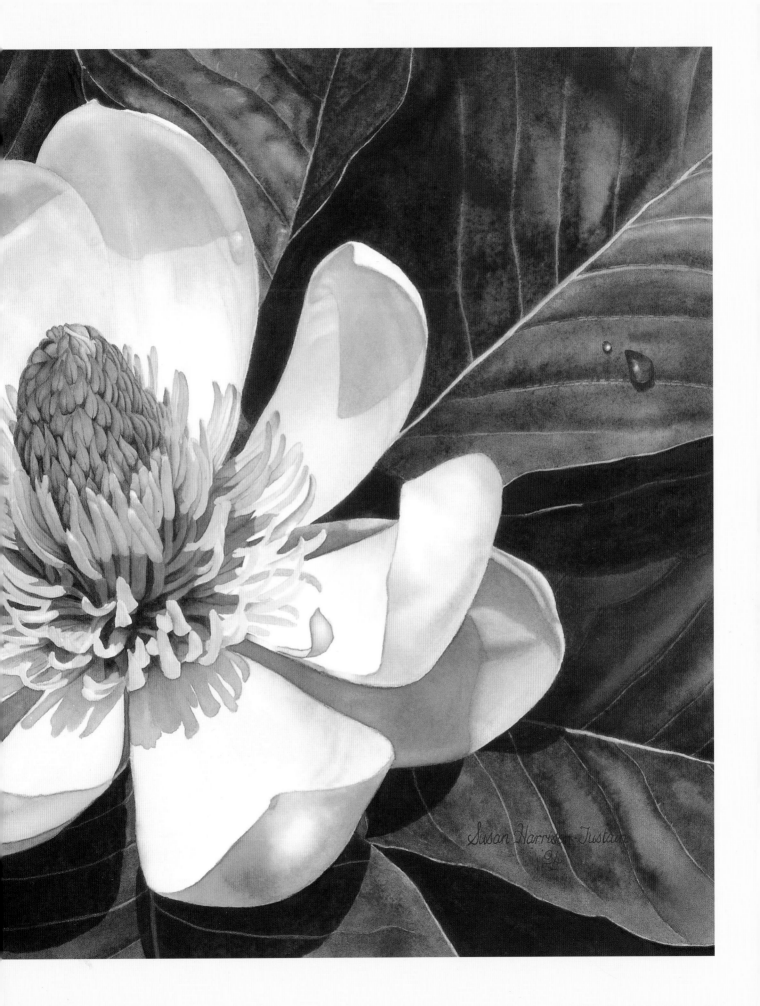

Susan Harrison-Tustain
96

Delicate Petals

Observation is the key to the successful rendering of your subject. Notice how these petals gently fold and turn, creating luminous shadows and soft highlights with few hard edges. The use of warm against cool hues molds the form, and cast shadows give the rose its depth. When painting gentle forms such as these, keep in mind the essence of the flower: the graceful fall of the petals, the soft interplay of light and shadow. I sometimes write down the key words that describe the essence of a subject I'm about to paint. I then occasionally refer to those words to ensure I'm keeping on track.

Materials

- Arches 140-lb. (300 g/m²) hot-pressed watercolor paper
- Schmincke watercolors
 Naples Yellow-Reddish
 Alizarin Crimson
 Ultramarine Blue Finest
 Cadmium Yellow Deep
 Permanent Red Orange
 Phthalo Blue

- Winsor & Newton Naples Yellow
- Maimeriblu Watercolors
 Primary Yellow
 Sap Green
- no. 2 and no. 4 brushes (Interchange the use of these brushes as you feel comfortable.)
- Schmincke masking fluid

1 Lay In Washes

Prime the paper, then lay in a watery wash of Winsor & Newton Naples Yellow in the yellow areas. Let dry. The pinkish hues can be painted in the same manner with a mix of Schmincke Naples Yellow-Reddish, a touch of Winsor & Newton Naples Yellow and Alizarin Crimson. The deeper yellow areas are fine washes of Maimeriblu Primary Yellow. Slowly build up your washes to the desired depth of hue.

Priming

The process of wetting, then re-wetting the paper to prepare it for the initial wash of color. (See page 30 for detailed information on priming.)

2 Build Form With Washes

Describe the petals on the two main flowers with varying depths of pink and yellow. The soft, blended effect is achieved by allowing the water to disperse the pigment, creating a gradation of depth in the pigment. Stroke the folds with denser pigment as you go.

Local Color

The basic color of an object, without the influence of sunlight, highlights and shadows. In step three, Naples Yellow and Alizarin Crimson are local colors.

3 Build Up Color and Shadows

Mask the stamens of the main flower with masking fluid; I use Schmincke masking fluid as it doesn't lift pigment when removing it from painted areas. Let dry completely, then continue to build up color in the required areas. Soften edges to describe gentle folds. Add a touch of Ultramarine Blue Finest to the local color to create soft shadows. Note how the cool shadows mold and describe the form of the petal. Build up a sufficient depth of color, then allow the painting to dry completely. Now wash over the entire flower with clear water, adding softness and continuity to your painting.

4 Add Shadow Washes and Stamens

Add the deeper shadows using a mix of Schmincke Ultramarine Blue Finest, Alizarin Crimson and Maimeriblu Primary Yellow. I vary the amount of each pigment according to the shadow color I see before me; some of the shadows are warm (yellow) while some are cooler (purple). Because shadows have a variety of color within them, start with the lightest mix—a predominantly yellow mix of shadow color in this case. Wet the shadow area and drop in the pigment where the shadow is most dense. Allow to dry after each application, then soften the edges with a damp brush of clear water. Softly blend the shadow colors into each other so there is a gradation from one color to the next. To achieve this prime the entire shadow area, then re-wet only the area you wish to cover plus a small margin more to allow the color to flare into the neighboring shadow color. Lay in the remaining shadow colors with a more blue or more purple mix. I used Cadmium Yellow Deep for the local color in the stamens; I then emphasized them with Schmincke Permanent Red Orange in the shadow and on the base. A touch of Ultramarine Blue Finest added to the red and yellow mix slightly deepens some of the stamens, adding definition where needed. The cast shadows from the stamens are the same variety of mixes used for the petal shadow; remember to make some warm and some cool. This gives variety and authenticity to your painting.

5 Complete the Centers

The style and stigma in the center of the flowers are painted with the same colors as the stamens. Once the local color wash is dry, use your shadow colors to make them "stand up." Paint the leaves, stems and buds with Primary Yellow.

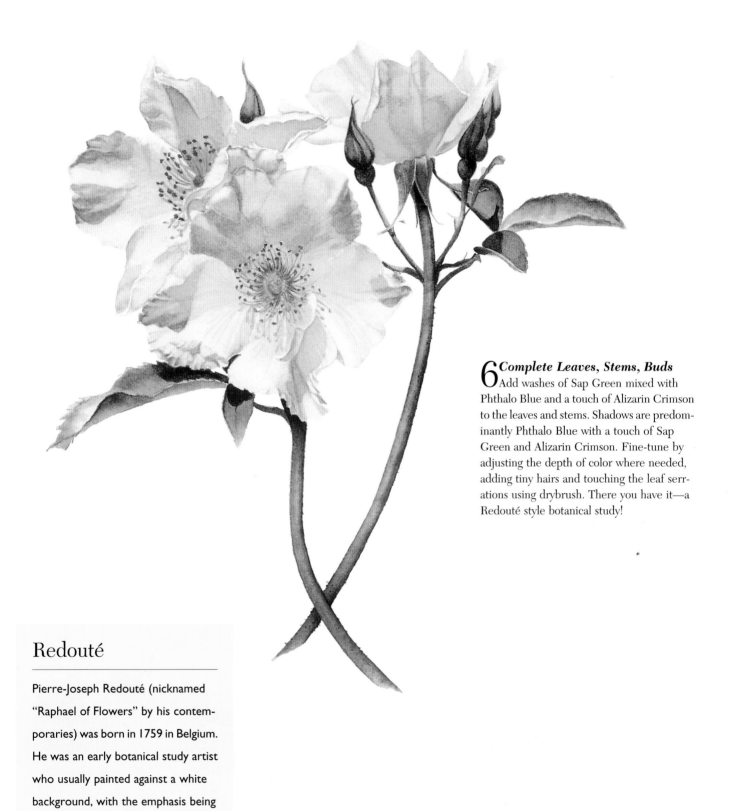

6 ***Complete Leaves, Stems, Buds***
Add washes of Sap Green mixed with Phthalo Blue and a touch of Alizarin Crimson to the leaves and stems. Shadows are predominantly Phthalo Blue with a touch of Sap Green and Alizarin Crimson. Fine-tune by adjusting the depth of color where needed, adding tiny hairs and touching the leaf serrations using drybrush. There you have it—a Redouté style botanical study!

Redouté

Pierre-Joseph Redouté (nicknamed "Raphael of Flowers" by his contemporaries) was born in 1759 in Belgium. He was an early botanical study artist who usually painted against a white background, with the emphasis being on the perfect rendering of the plant. He died at the age of eighty-one in 1840.

Leathery Petals

A leathery petal will usually have thick rims and few creases—certainly no sharp ridges or folds. As thick-textured petals are often opaque, I like to use an initial light, opaque wash to give the petal body. It's important to choose pigments whose properties best describe the almost rubberlike feel of these petals. All the petals in this magnolia are painted in much the same manner as this initial petal.

Materials

- Arches 140-lb. (300 g/m²) hot-pressed watercolor paper
- Schmincke watercolors
 - Naples Yellow
 - Alizarin Crimson
 - Cadmium Yellow Deep
 - Ultramarine Blue Finest
 - Indian Yellow
- no. 4 and no. 12 da Vinci Maestro sable brushes, series 11

1 Lay In Opaque Wash
Prime the petal and lay in a wash of Schmincke Naples Yellow. This opaque base will give the petal body.

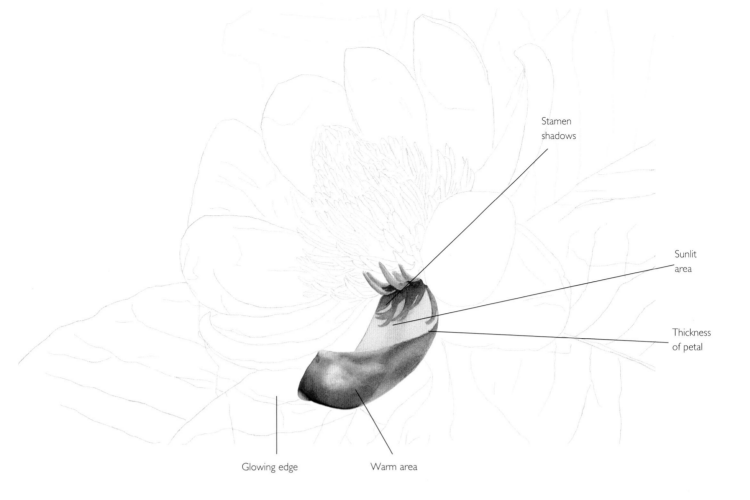

Stamen shadows

Sunlit area

Thickness of petal

Glowing edge

Warm area

2 Describe the Rims

Work on the sunlit area first, as this is the lightest spot. Prime again, this time allowing the second wetting to be absorbed into the paper—but remaining moist—before adding color. Start at the left-hand edge and run a very pale, almost dry brush mix of Alizarin Crimson and Cadmium Yellow Deep along the rim of the petal. The highlight that runs along the rim on the other edge describes the thickness of the petal. Keep it in mind as you build up the layers of the sunlit part of the petal; if you merge this edge with the main area of the petal, you will lose the feeling of thickness so necessary to give the petal its character. Prime the sunlit area again. Now, working on a slightly moist surface, drop in very pale mixes of Alizarin Crimson, Ultramarine Blue Finest and Cadmium Yellow Deep. These washes are hardly tangible, but you'll find if you build them up slowly, the petal will become concave and acquire depth. The edges will gently blend and flare into the lighter, brighter upper areas of the curve. Prime the outer, shaded surface and drop in a wash of Cadmium

Yellow Deep in the yellow areas, particularly the glowing left-hand edge. Notice the warm area running almost the length of the underside. Use Schmincke Indian Yellow here; if used in a pale enough wash, this transparent color should give a subtle warmth, hinting at the sunlight on the other side of the petal. Allow to dry, then prime the entire outer side again, applying only a small amount of moisture to the glowing edge. Drop in a mix of Cadmium Yellow Deep and Alizarin Crimson on the left side, keeping the pigment from invading the glowing yellow edge. Now build up the right-hand side with a cooler mix of Alizarin Crimson. Dry again, prime, then drop various wash mixes of Alizarin Crimson, Indian Yellow and Ultramarine Blue Finest to give the effect of shadow. Finish by painting the stamen shadows with a warm wash of predominantly Indian Yellow mixed with Alizarin Crimson and Ultramarine Blue Finest. Complete the other petals in the same manner.

Folds and Veins

Folds, creases and veins give form and grace to petals. I've chosen one of my favorite flowers, *Papaver orientalis*, to demonstrate my techniques for creating these textures. This particular poppy, with a bloom as big as a dinner plate, grew in a lovely cottage garden in southwest England. It never ceases to amaze me how such a magnificently large flower can be folded so compactly and held within a relatively small bud. Its strong, vibrant color and gentle folds entranced me. Look at the painting with one eye closed and use your finger to block out some of the creases. See how directionally forceful the petals become when you remove your finger?

Materials

- Arches 140-lb. (300 g/m²) hot-pressed watercolor paper
- Schmincke watercolors
 - Cadmium Yellow Deep
 - Cadmium Yellow Light
 - Cadmium Orange Deep
 - Cadmium Red Deep
 - Alizarin Crimson
 - Phthalo Green
 - Phthalo Blue
 - Titanium White
- Maimeriblu Sap Green
- no. 0, no. 2 and no. 4 brushes (optional: an old sable brush with very few hairs)

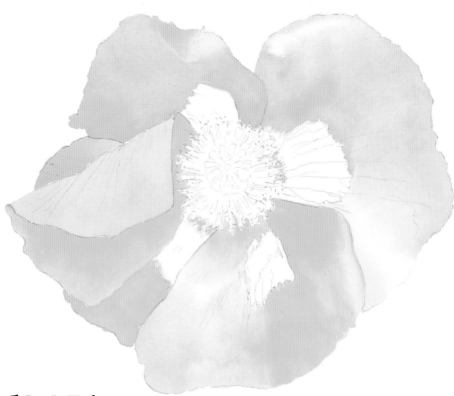

1 Lay In Wash

Lay in a wash of Cadmium Yellow Deep using a no. 2 brush. Use a thinner wash in the highlight areas. Allow to dry.

2 Build Up Form

Build up the depth of color by laying in a number of fine washes, beginning with Cadmium Orange Deep, keeping the highlight areas in mind. Allow to dry, then add a wash of Cadmium Red Deep. Build up denser pigment to describe the folds and shadow areas. Add the fine lines to indicate the creases in the petals; the form of the petals should now be evolving.

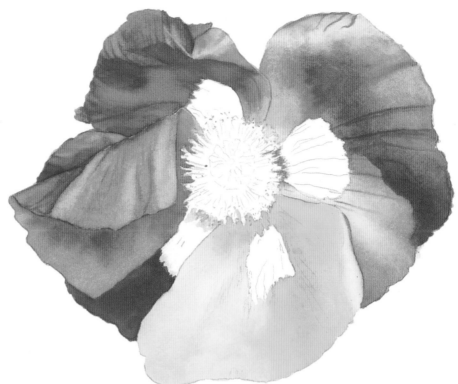

Concave, lightly shadowed area

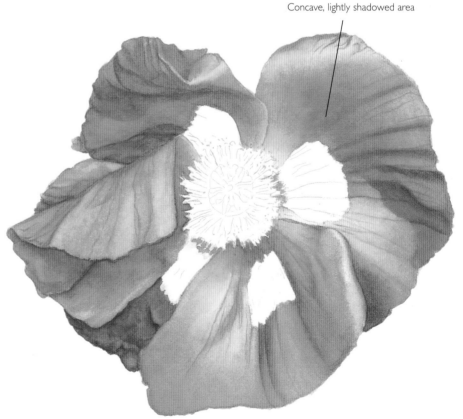

3 Describe the Shadows

I usually choose a mix including Ultramarine Blue Finest for shadows, but Sap Green appears more natural in this study. Prime shadow areas using a no. 4 brush, leaving a margin to allow soft blending. Dampen again, keeping just within the primed area (this method is discussed on page 40). Drop in a mix of Sap Green, Alizarin Crimson and Cadmium Red Deep. Describe the deeper folds and shadow areas with a darker mix of this shadow color. You'll need to use more Sap Green in some areas. Keep the highlight areas in mind—try not to paint over areas where the white paper or yellow underpainting need to show through. Often a highlight is juxtaposed next to a shadow, emphasizing the highlight. Notice a concave area on the right petal that looks like it's not in shadow. When you add a small amount of shadow color to this area, the petal appears to fold gently. If necessary, lift color out of the highlights.

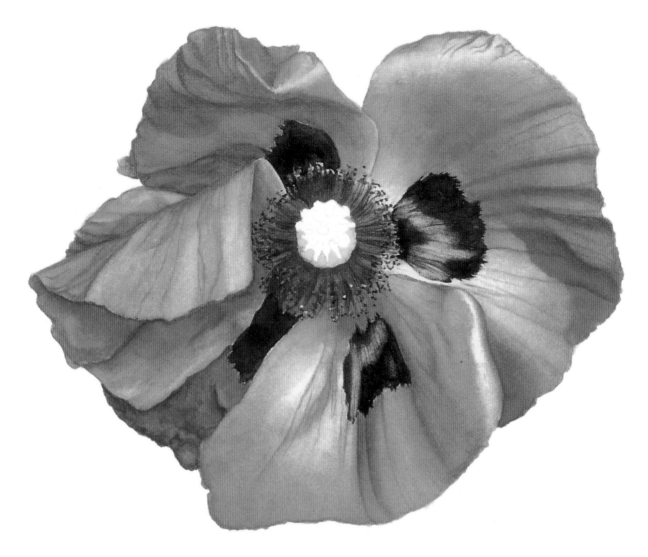

4 Paint the Black Spots and Stamens

Can you see how crisp and clean the black spots are? This is achieved by using a mix of Alizarin Crimson, Phthalo Green and a little Phthalo Blue. This black can be pushed from warm to cool simply by adjusting the amount of Alizarin Crimson or Phthalo Green used. I never use premixed black from a tube. While the black is still damp, lift out highlighted areas; see how the petals shine with just this one addition! When drawing and painting stamens, study the specific form they should take. Generally there are at least a few "rebels" that separate and twist away from the rest. These add authenticity and realism. Paint the stamens a pinker (more Alizarin Crimson) version of the black mix. I used an old sable brush with about six hairs left for this step. The green seedpod is painted in a series of glazes, starting with Cadmium Yellow Light.

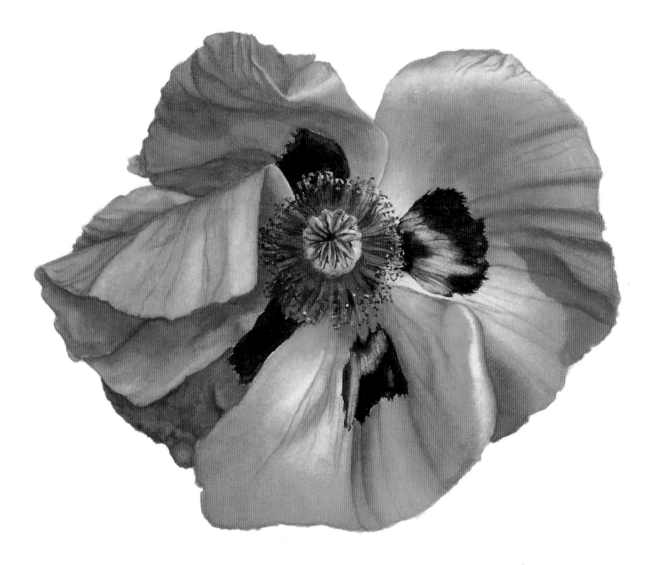

5 *Complete the Center*

Add a wash of Phthalo Green mixed with a touch of Phthalo Blue for the shadowed lower areas of the seedpod. Use a pinker version of the black mix to paint in the stigma; add a touch of Cadmium Yellow Deep to the warmer areas. Darken the shadows and lift out additional highlights where needed. Spot the seed head with Schmincke Titanium White using no. 0 brush mixed with a little Alizarin Crimson. Don't forget some of the stamen are in shadow, so these will have *a touch* of Phthalo Green added to the stamen mix.

Creased Petals

It's fun to paint petals that have creases and ribs. As with the poppy, the lines assist us in describing the direction in which the petal falls. Sometimes a study like this can seem like a maze of folds and creases—you may initially wonder where to start. The best solution for anything that seems a little daunting is to break it down into sections rather than looking at the whole picture. Good observation is fundamental to the successful painting of realistic folds and creases. As the creases create ridges, so too do they create thrown shadows. We can describe this convincingly using a warm-against-cool and dark-against-light approach. Spend some time looking at the demonstration, and note that the majority of the flower is painted with just four colors, ranging from yellow to Ultramarine Blue Finest. The shadows are a mix of two or three of these colors; I allow one color to dominate each shadow to give the overall temperature required. This is an important principle to understand, as you can apply it to any subject.

Materials

- Arches 140-lb. (300 g/m²) hot-pressed watercolor paper
- Schmincke watercolors
 - Indian Yellow
 - Alizarin Crimson
 - Ultramarine Blue Finest
- Maimeriblu watercolors
 - Primary Yellow
 - Sap Green
- no. 2 and no. 4 brushes

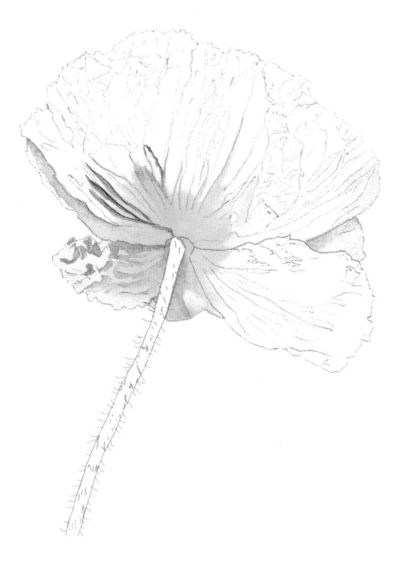

1 Lay In Basic Colors
Prime the entire surface of all flower petals using your no. 4 brush. Drop in a very pale wash of Primary Yellow and allow the water to direct the flow. To achieve the soft edges of the creases, you will need to paint on paper that has all but dried. If the paper feels cool to the ball of your hand, you still have a very small amount of residual moisture, which is ideal. Lay in varying mixes of Ultramarine Blue Finest, Alizarin Crimson and Primary Yellow in the creases using a no. 2 brush. Begin describing thrown (cast) shadows. Note how the highlighted ridges pop up once the shadow color is applied.

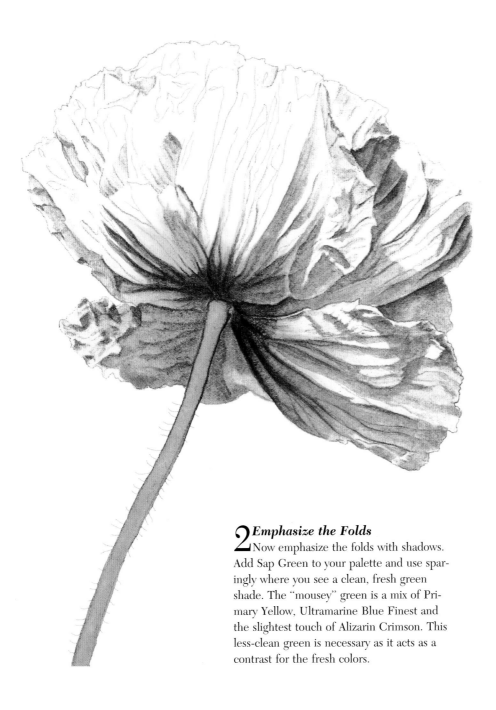

2 Emphasize the Folds

Now emphasize the folds with shadows. Add Sap Green to your palette and use sparingly where you see a clean, fresh green shade. The "mousey" green is a mix of Primary Yellow, Ultramarine Blue Finest and the slightest touch of Alizarin Crimson. This less-clean green is necessary as it acts as a contrast for the fresh colors.

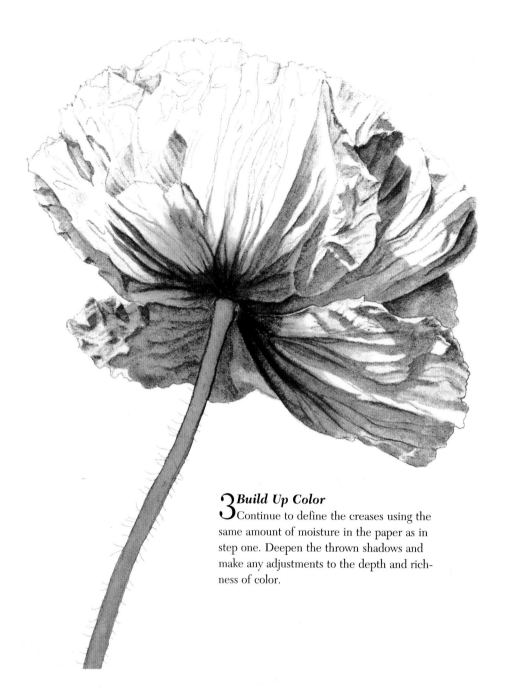

3 Build Up Color

Continue to define the creases using the same amount of moisture in the paper as in step one. Deepen the thrown shadows and make any adjustments to the depth and richness of color.

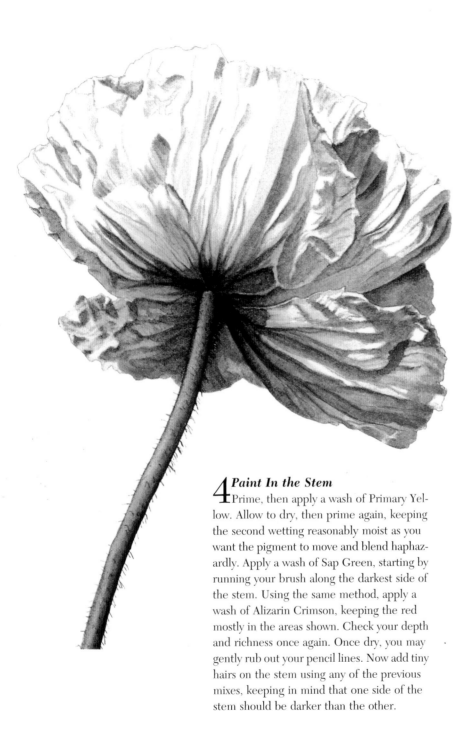

4 *Paint In the Stem*

Prime, then apply a wash of Primary Yellow. Allow to dry, then prime again, keeping the second wetting reasonably moist as you want the pigment to move and blend haphazardly. Apply a wash of Sap Green, starting by running your brush along the darkest side of the stem. Using the same method, apply a wash of Alizarin Crimson, keeping the red mostly in the areas shown. Check your depth and richness once again. Once dry, you may gently rub out your pencil lines. Now add tiny hairs on the stem using any of the previous mixes, keeping in mind that one side of the stem should be darker than the other.

Veined Leaves

There are many different shapes, textures and colors of leaves. I invariably begin my initial drawing with the central vein or midrib; it stands to reason that the rest of the leaf follows this basic form. The reflective quality of the leaf also needs to be considered—each is handled differently. Avoid describing too much detail in the background; in general, only the leaves in the foreground need detail. Suggesting leaf shape and color in the background portrays distance and leaves a little mystery for the viewer.

Materials

- Arches 140-lb. (300 g/m²) hot-pressed watercolor paper
- Schmincke Phthalo Blue
- Maimeriblu watercolors
 Primary Yellow
 Sap Green
- no. 2 and no. 4 brushes

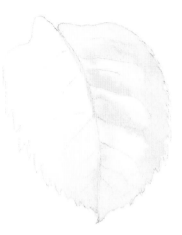

1 Lay In Washes

Complete a line drawing beginning with the central vein, or midrib. Using a no. 4 brush, prime half of leaf with clear water, avoiding the highlights. Allow the water to evaporate just enough so the sheen has been absorbed—there should be just enough moisture left in the paper from the first wash to avoid hard edges forming around the highlights. Leaves often have a warm and cool side. Keeping this in mind, lightly lay a wash of Primary Yellow on the warm side, including the central vein. Once this is dry you can prime the cool side and lay in a very pale wash of Phthalo Blue, avoiding the lightest highlighted area.

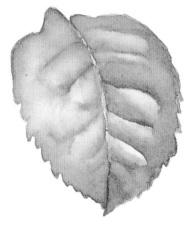

2 Add Sap Green

Sap Green is ideal for many leaves because it's rich, transparent and mixes well with other hues. Prime each area on the warm side of the leaf. Drop in Sap Green at the darkest points, allowing the water to disperse the pigment for you. If the pigment doesn't move, it's because you need to use more water, either in the redampening stage or in your paint-loaded brush. Prime the cool side of the leaf and dampen again as before, avoiding the highlighted area.

Warm Side, Cool Side

Describing a leaf is made easier by the fact that one side of a leaf often faces the sunlight while the other falls away from it. Simply use warm yellows and greens (those closer to red) for the warmer side, and cooler yellows and greens (those closer to blue) for the cooler side. Primary Yellow can be warmed or cooled by the addition of a touch of Phthalo Blue or Alizarin Crimson. Some cool highlights can be described by nothing more than a simple thin wash of Phthalo Blue.

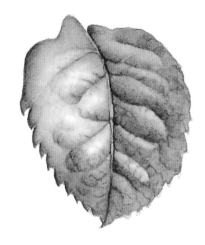

3 Indicate the Veins

With a fine no. 2 brush, pick up a light mix of Phthalo Blue to which just a touch of Sap Green has been added. Indicate the minor veins lightly, remembering to shape these lines so they appear to follow the form of the leaf section. Allow the dampness of the paper to draw the pigment up to the highlighted edge, where it should blend softly. If the paper is drying too quickly, you may want to use two brushes—one dampened with clear water and the other with pigment. Run the clear water brush along the vein, then immediately stroke the vein with the pigmented brush.

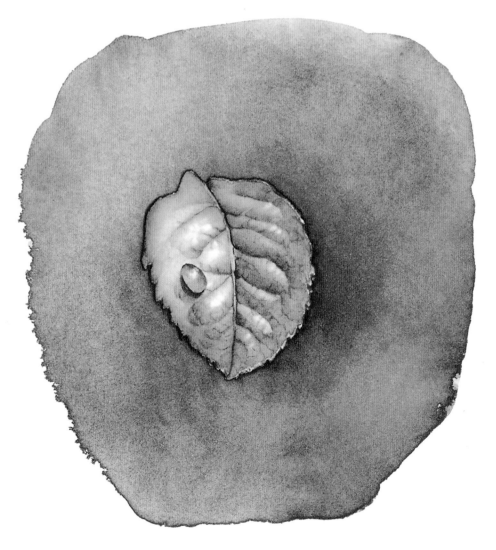

4 Finish the Leaf

Deepen areas that require more definition, such as indentations and shadow areas. The dry-brush technique can be used to further define the central and lesser veins; highlights on the very edge can be added when painting the background. Have a little fun by adding a dewdrop (see pages 74-75) just to finish it off!

black

Smooth, Shiny Leaves

Now let's look at a smoother, shinier leaf with less promi-
nent veins. Smooth leaves don't have ridges that catch the
light or cast shadow. The form is predominantly defined with
larger patches of warm hues, cool hues and blended highlights.
Make a mental note of highlights, rich deep areas and the tones
between them. The tones are more blended than in the previ-
ous example, which relied on light against dark to describe the
form.

Materials

- Arches 140-lb. (300 g/m²) hot-
 pressed watercolor paper
- Schmincke watercolors
 Phthalo Blue
 Alizarin Crimson
- Maimeriblu watercolors
 Primary Yellow
 Sap Green
 Dragon's Blood
- no. 2 and no. 4 brushes

1 Lay In Washes
Prime, as in initial stages of the veined
leaf, with a no. 4 brush, then pick out the
highlights with a light wash of Phthalo Blue.
At this point you could also lay in a wash of
Primary Yellow if your paper is still damp,
avoiding the highlight areas. If the paper is
dry, prime and add a yellow wash. Allow to
dry.

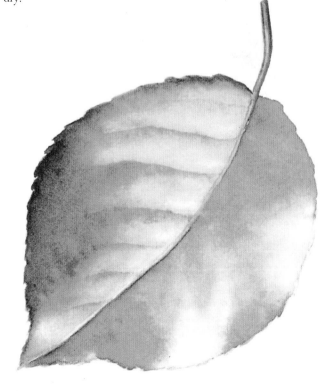

2 Describe Form
I have kept the right side plain, using highlights to describe form.
Prime one side of your leaf. Drop in a mix of Sap Green and Primary
Yellow. You could add a touch of Phthalo Blue in the area closest to
the rib, cooling down the color slightly and giving the leaf form. Now
prime the other side of the leaf. Slightly dampen the vein area; pick
up a small amount of pigment on your brush and run it along the vein.
Allow this to dry, then prime and moisten the area at the left edge of
the leaf again. Drop in a mix of Sap Green, Primary Yellow and a small
amount of Phthalo Blue, letting the water blend your pigment gradu-
ally with the highlights. On the very edge you can add a touch of
Alizarin Crimson and watch the leaf turn before your eyes!

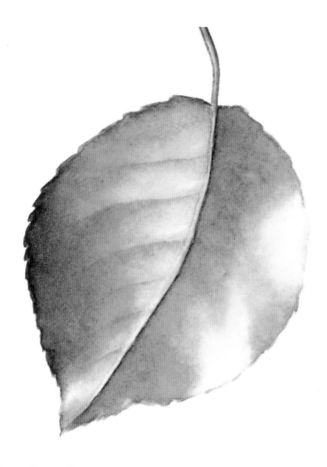

3 Complete the Leaf

Once all is dry, fine-tune the leaf. Deepen the green if necessary to give a richer depth of hue. Using a dry-brush method and a no. 2 brush, gently add a narrow shadow line along the right side of the spine. I often finish off by drybrushing some of the serrations with Dragon's Blood, a Maimeriblu color I adore. (You can mix a similar color using Ultramarine Blue Finest, Alizarin Crimson and Burnt Sienna.) Notice how the small highlight at the base of the leaf on the left lifts that area, while the cooler addition of Phthalo Blue next to the highlight drops it back down to form a fold.

Adding Life to Your Florals

There's something magical about dewdrops, bumblebees, cicadas, butterflies, ladybugs, withered flowers and chewed leaves. These final touches give life and movement to your painting. It's good to be mindful of the natural habitat of the insect you choose: A monarch caterpillar would look incongruous on a pine branch. You'll also need to give some thought to the surface and shape of the object you place the insect on. The trompe l'oeil (literally "fool the eye") effect we are trying to achieve can so easily be lost by placing an insect on an unnatural angle. The stance of the insect must be in keeping with the perch. There are many reference books on insects, but also keep your camera "on the ready" for those fleeting moments when a bumblebee nestles in the stamens of a flower then flies off laden with her golden treasure. Photographs taken at any of these stages can be useful.

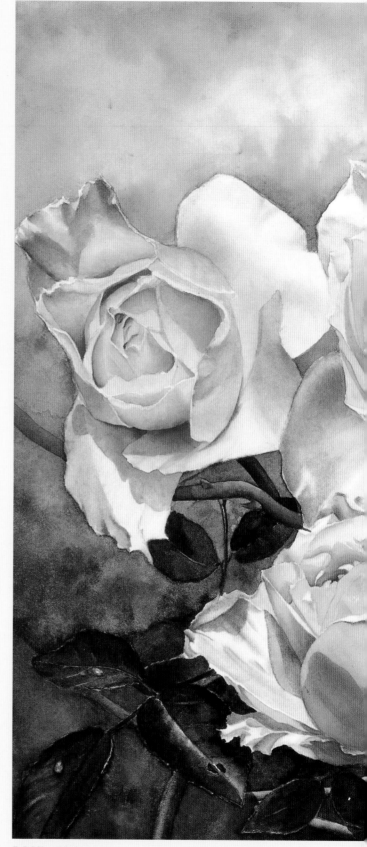

ROSE "TROILUS"
watercolor on Arches 140-lb. (300 g/m²) hot-pressed watercolor paper, 14½″ × 20″ (37cm × 51cm), private collection

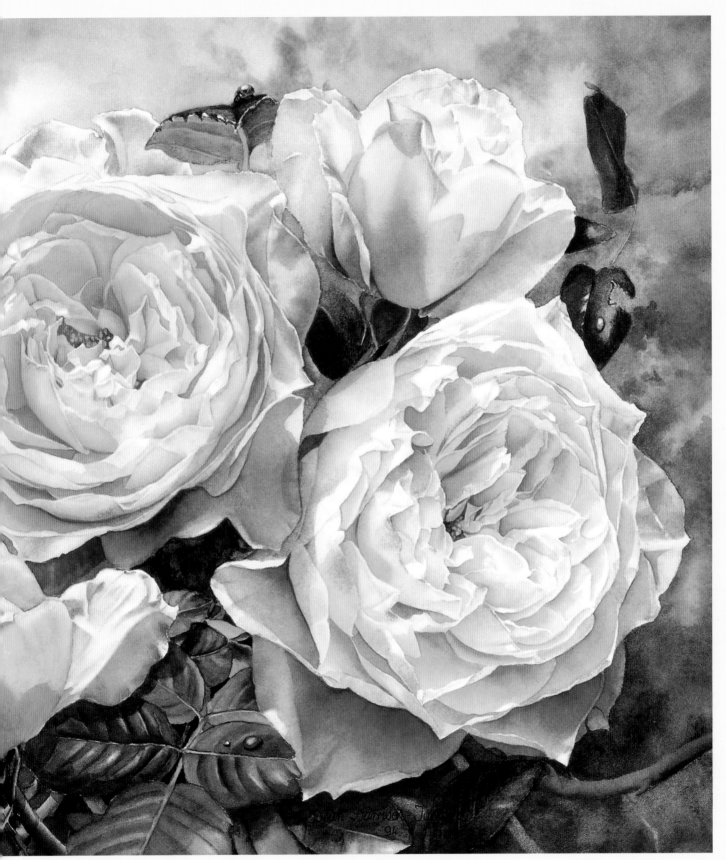

The epitome of the David Austin English roses, the splendid, cabbagelike blooms appeared to capture the early evening light and bounce it around, creating a warm glow and altering the color of the rose amazingly from a lovely buff shade to this sumptuous apricot luminescence. The foraging ladybug on the top leaf is blissfully unaware of us looking on.

Dewdrop on Leaf

Listen to your viewers "ooh" and "ahh" when they spy the glistening drop, especially if it looks as if it's just about to roll off the petal or leaf. Best of all, dewdrops are so easy to create!

Bear in mind that every dewdrop is different. Place a droplet of water on a waterproof surface in front of you, and study it for a while. See how transparent and yet reflective the droplet can be? Dewdrops look three-dimensional because they use the "light-against-dark, dark-against-light" theory so effectively. Following are some hints for creating dewdrops:

- Dewdrops are always the same local color (the color of the leaf or petal when unaffected by light and shade) as the surface they're sitting on.
- To be convincing, the light source must match that hitting your main subject.
- The area closest to the light source is always darker than the opposite end.

PLANNING THE HIGHLIGHT

Before you start, decide how you prefer to portray your highlight. I usually leave a small area of white paper, but if I'm adding a dewdrop as an afterthought, I use an electric eraser to lift a white area out of the color. Other options are: saving a white area with masking fluid, using a knife to lift the color or applying a dab of white paint. If you choose to leave the paper white or use masking fluid, you will need to incorporate that into step one. The other methods can be carried out in step three.

1 Draw Your Droplet

If you wish to leave a white area or mask an area for the highlight, do so before painting the leaf. Bear in mind the angle of the leaf, petal, etc. A stationary-looking drop isn't quite as credible on a vertical surface.

Materials

- Arches 140-lb. (300 g/m²) hot-pressed watercolor paper
- Schmincke watercolors
 - Alizarin Crimson
 - Ultramarine Blue Finest
- Maimeriblu Sap Green
- Winsor & Newton Aureolin
- no. 4 da Vinci sable brush

2 Drop In Color

Wet the area inside your droplet. I like to add a touch of yellow to most dewdrops for a warm, transparent glow. I usually choose Aureolin or Indian Yellow due to their transparency. Simply wet the drop and allow a fine wash of yellow to flow in over the mid to lighter value areas. Dry. Re-wet and use a damp brush to pick up a darker value of your local color. Drop this in the area closest to the light source and around the edges of the droplet. The color will be darkest where your brush makes initial contact with the paper. Allow the water to blend this value so it has a gradational effect, making sure the outer edge is accentuated with deeper pigment. If the pigment is flowing too freely and not concentrating where you wish it to, simply tip your paper slightly or allow the water to be absorbed a little more before re-applying. Allow to dry.

3 Add Shadow and Highlight

When the paper is completely dry, paint in the cast shadow, which is generally a mix of local color (in this case Sap Green), its complementary (Alizarin Crimson) and Ultramarine Blue Finest—occasionally I will use Phthalo Blue instead. If you masked your highlight, remove the masking fluid now. If you chose to use a lifting method, erase or lift an area the size and shape of your desired highlight and watch how the dewdrop "pops" to the surface.

Dewdrop on Petal

The steps for painting this dewdrop are exactly the same as in the previous demonstration. Only the local color changes.

Materials

- Arches 140-lb. (300 g/m²) hot-pressed watercolor paper
- Schmincke watercolors
 Brilliant Purple
 Ultramarine Blue Finest
- Winsor & Newton Aureolin
- Maimeriblu Sap Green
- no. 4 da Vinci sable brush

1 Draw Your Droplet
If you wish to leave a white area or mask an area for the highlight, do so before painting the petal.

Shadows for Purple Flowers

The most suitable shadow color for purple flowers is Phthalo Green. The complementary of purple is yellow, but experience shows that yellow just doesn't work when glazed or washed over purple; it becomes muddy and doesn't give a shadow color at all. This is especially true when using a yellow that is made up of a high degree of white.

2 Drop In Color
Wet the area inside your droplet. Allow a fine wash of yellow to flow in over the mid to lighter value areas. Dry. Re-wet and use a damp brush to pick up a darker value of your local color. Drop this in the area closest to the light source and around the edges of the droplet. Allow the water to blend this value so it has a gradational effect, making sure the outer edge is accentuated with deeper pigment. Allow to dry.

3 *Add Shadow and Highlight*

When the paper is completely dry, paint in the cast shadow, which is generally a mix of local color, its complementary and Ultramarine Blue Finest or Phthalo Blue. If you masked your highlight, remove the masking fluid now. If you chose to use a lifting method, erase or lift an area the size and shape of your desired highlight.

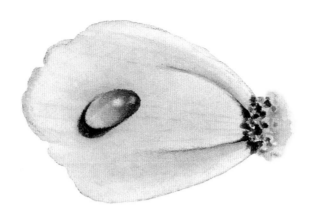

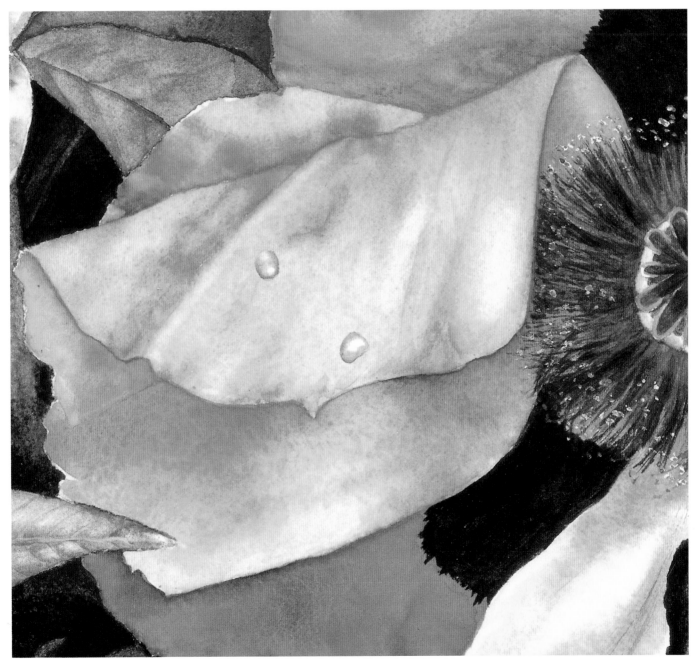

detail

PAPAVER ORIENTALE
watercolor on Arches 140-lb. (300 g/m²) hot-pressed watercolor paper,
12½″ × 18″ (32cm × 46cm), private collection

Chewed Leaves

Chewed leaves add a "truth" to a painting—you will seldom find a flower in nature that is entirely perfect; they create added interest and authenticity to your study of nature. Following are two methods of creating the effect of a chewed leaf.

Materials

- Arches 140-lb. (300 g/m²) hot-pressed watercolor paper
- Schmincke watercolors
 - Phthalo Blue
 - Alizarin Crimson
 - Burnt Sienna (optional)
 - Cadmium Orange Deep (optional)
- Winsor & Newton Aureolin
- Maimeriblu watercolors
 - Sap Green
 - Dragon's Blood (optional)
- no. 4 da Vinci sable brush

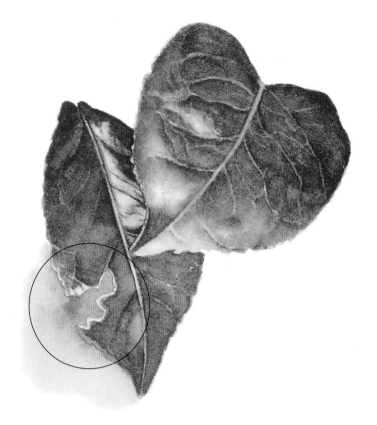

Allow Background to Show Under Leaf

Complete the leaf as you would normally, but leave a jagged, chewed edge in one area. Now draw a narrow line outside the chewed area of the leaf, following the shape of the chewed area. This will create a white band, as shown. Paint in your background up to the white section. Once dry, you can add random areas of Dragon's Blood, Burnt Sienna or Cadmium Orange Deep to the rough edges to give the bug bites an aged, bruised look.

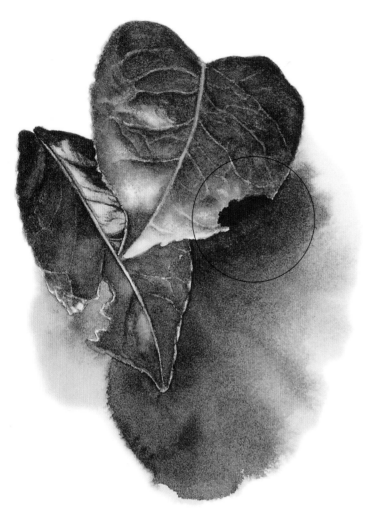

Overlap Leaf With Background Color

It's best to plan where you wish the chewed area to be before adding pigment, but all is not lost if you choose to add a chewed area later, as long as the background or underneath color is darker than the leaf. Simply paint in your background and allow the color to overlap the leaf, creating a chewed shape. The darker background color will cause this area to recede. This method won't produce a white edge, as in the previous technique, but it can still be very effective.

Withered Flowers

Have you ever spent time looking at withered flowers? We are often so overawed by the beauty of new buds and open blooms that we tend to neglect the final stage in the life story of flowers.

There is an inherent naturalness and beauty in these spent blooms that gives a painting character, personality and honesty. Withered, wrinkled petals are painted using the same method as de-

scribed in chapter four for creased petals. The inclusion of this single feature lifts the painting below out of the ordinary.

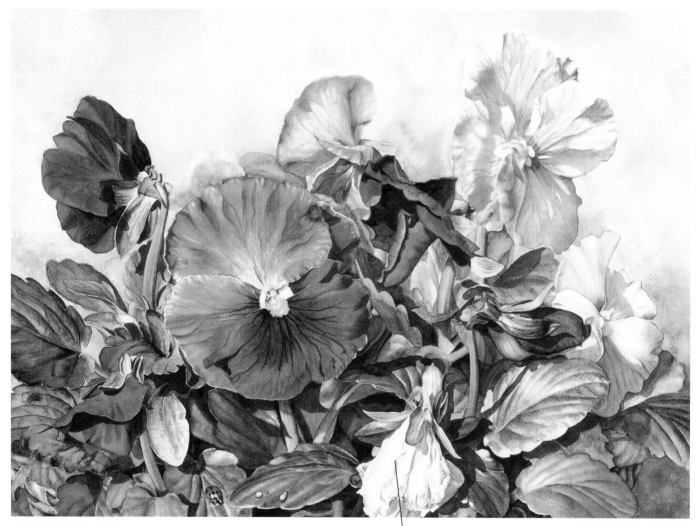

ANTIQUE SHADES
watercolor on Arches 140-lb. (300 g/m²) hot-pressed watercolor paper,
18¾"×21" (48cm×53cm)

Withered flower

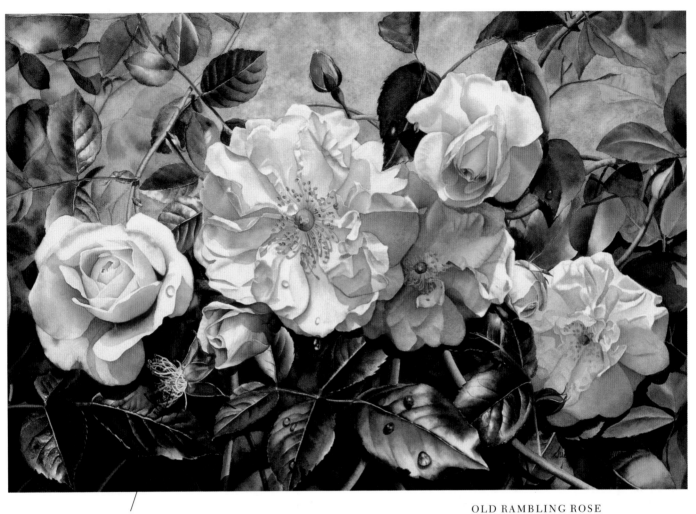

Spent flower

OLD RAMBLING ROSE
watercolor on Arches 140-lb. (300 g/m²) hot-pressed paper, 14" × 20" (36cm × 51cm), private collection

The twisted stamens of blooms that have long since lost their petals have their own special beauty. Keep in mind the anthers and stamens not only take on a different form but are often a different color from those within fresh, new blooms. The sepals often turn themselves outward, revealing a soft, velvety bloom. It's attention to this sort of detail that gives your painting a "presence."

Bumblebees

I've demonstrated three bumblebees at different angles to help you see how easy they are to arrange in your composition. I paint all my insects simply by laying glaze over dried glaze until I have the density of color I require. (I occasionally use washes when the area is larger.) Remember to keep your whites white or just barely off-white. You can tone them down if necessary in the final stage. The shadows are transparently painted in during the final stage and blended carefully with a clear water wash (where highlight meets shadow) to mold the body shape.

Materials

- Arches 140-lb. (300 g/m²) hot-pressed watercolor paper
- Schmincke watercolors
 - Indian Yellow
 - Alizarin Crimson
 - Phthalo Green
 - Ultramarine Blue
 - Phthalo Blue
 - Titanium White (optional)
- Winsor & Newton Transparent Yellow
- no. 4 da Vinci sable brush

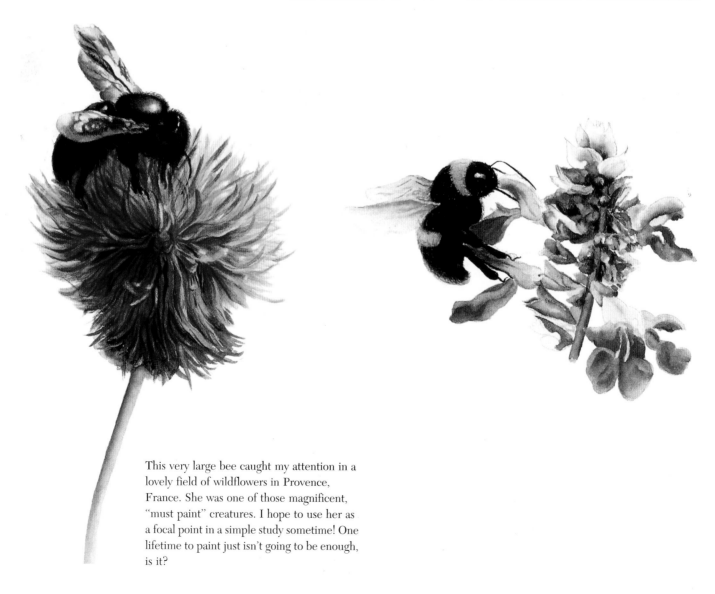

This very large bee caught my attention in a lovely field of wildflowers in Provence, France. She was one of those magnificent, "must paint" creatures. I hope to use her as a focal point in a simple study sometime! One lifetime to paint just isn't going to be enough, is it?

1 Apply Underwash

I like a rich undercoat of Indian Yellow on the body. The tail is painted with the magical black mix of Alizarin Crimson and Phthalo Green. You can lightly paint the wings with a watery glaze of Indian Yellow.

2 Build Detail

When the wings are just about dry, add a touch of Ultramarine Blue Finest mixed with a tiny amount of Alizarin Crimson to the shadow areas on the left wing. You'll need to float a wash of Ultramarine Blue Finest on the right wing to achieve the soft blending at the front. Once again mix your black using Alizarin Crimson and Phthalo Green. Float this mix in as shown, still avoiding the highlights. Add a touch of Phthalo Blue to the black mix and apply it to the right side of the body. This cools down the black and helps mold the form (one side warm, the other cool). Drybrush Transparent Yellow on the tail end, allowing some of the white paper to show through. If required, you can define the fine hairs with a little white body color.

3 Fine-Tune

The bee looked unbalanced with only one leg visible, even though this is how it was in reality. I added the suggestion of a second leg.

Bees to the Rescue

Bumblebees can also come to the rescue if you have dropped a loaded brush right in the middle of your flower. Simply turn the splotch into a bee, saving your painting and at the same time adding life and movement.

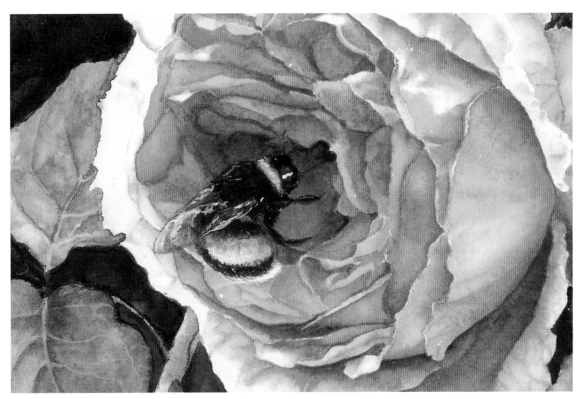

detail
ROSE "PARADE"
watercolor on Arches 140-lb. (300 g/m²) hot-pressed watercolor paper, 20″ × 14½″ (51cm × 37cm), private collection

Butterflies

I love to see butterflies with petal-like wings wafting amongst the blooms and foliage. I've demonstrated two varieties: a regal monarch and a colorful butterfly that was a frequent companion on my walks through the countryside of Provence, France. Painting this second butterfly takes my thoughts back to those amazingly characterful streets, gardens, window boxes and glorious fields with their abundance of wildflowers. My passion for painting has made these trips so much richer and more exciting. Before taking my painting seriously, I would drive past fields of poppies and wildflowers and think how beautiful they were; now I stop the car and "experience" being part of nature. I spend hours observing flowers and grasses and studying the amazing insect life. Then, when it comes to painting them, I relive those wonderful, seemingly endless, balmy summer days in Provence.

Materials

- Arches 140-lb. (300 g/m²) hot-pressed watercolor paper
- Schmincke watercolors
 - Alizarin Crimson
 - Indian Yellow
 - Phthalo Green
- Winsor & Newton Transparent Yellow
- no. 4 da Vinci sable brush

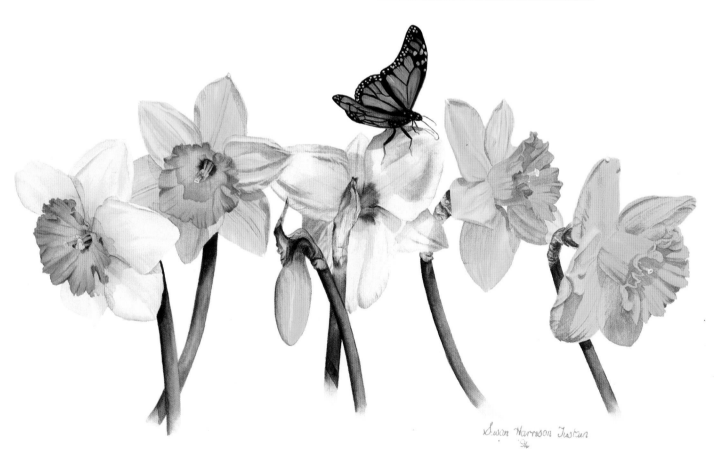

DAFFODIL DAYS
watercolor on Arches 140-lb. (300 g/m²) hot-pressed watercolor paper,
11½″ × 19½″ (29cm × 50cm), private collection

MONARCH BUTTERFLY

1 Lay In Wash
Prime the wings, leaving the white spots untouched. Now drop in a wash of Transparent Yellow. Allow to dry.

2 Mold the Form
Prime again and drop in a mix of Alizarin Crimson and Indian Yellow, starting at the edge and allowing the priming wash to pull the pigment up and over the wings.

3 Add Rich Black
Now mix a rich, dark, velvety black with Alizarin Crimson and Phthalo Green. Apply this wet-on-dry to the dark areas. You will need to build up a few layers of this mix to achieve a rich, deep black. Allow each layer to dry before adding the next.

4 Soften the Black Lines
Gently wet the orange areas, allowing the brush to also wet the black edges. The black will flare into the orange area, thus eliminating hard demarcation lines and giving a softer, more gentle look. Deepen areas that require richer color. Take care when rendering the spots; some are yellow and some white.

EUROPEAN BUTTERFLY

Exploring the streets of the beautiful village of Tourtour in Provence, France, I came across several of these elusive butterflies. This particular one fluttered around evasively, then, just as I was about to give up, she posed for several minutes on this flower—just to make sure I captured her best side, I'm sure!

Materials

- Arches 140-lb. (300 g/m²) hot-pressed watercolor paper
- Schmincke watercolors
 Indian Yellow
 Phthalo Blue
 Ultramarine Blue Finest
 Alizarin Crimson
 Brilliant Purple
 Phthalo Green

- Winsor & Newton watercolors
 Naples Yellow
 Transparent Yellow
- no. 4 da Vinci sable brush

1 Lay In Washes on Wings

Prime, then lay in a wash of Naples Yellow over the entire butterfly wings. Take care to avoid the body. Now study the painting; you'll notice areas that are blue, some that have a pink tinge and some that are predominantly yellow. The blue areas are a mix of Phthalo Blue and Ultramarine Blue Finest. The pink areas are a thin mix of these two blues, then a touch of Alizarin Crimson. You'll note the pale areas that seem predominantly yellow actually have a very fine wash of these two blues over the yellow underwash.

2 Detail Wings and Body

Enrich the colors by adding more fine layers of the mixes described in the first step. I have emphasized there are four wings by laying in a shadow—made from Transparent Yellow, Alizarin Crimson and Phthalo Blue—under the upper wings. The black is a mix of Alizarin Crimson and Phthalo Green. I used a dotting stroke to apply this. The bright yellow is Indian Yellow. The bright blue spots are Ultramarine Blue Finest. The veins are varying mixes of Phthalo Green and Alizarin Crimson, sometimes favoring green, sometimes red. The body is painted using the same black mix; keep some white paper to give the impression of hairs. Once the body is dry, lightly brush clear water over the hairs to blend them in. The flower is painted with varying mixes of Brilliant Purple, Indian Yellow and Ultramarine Blue Finest.

Cicadas

The song of the cicada has to be the epitome of the long, hot, lazy days of summer, evoking memories of picnics, barbecues, the beach, holidays and happiness. By including an appropriate insect in your work, your viewer will sense the atmosphere you are trying to create.

1 Lay In Wash
Prime the body of the cicada, avoiding areas to remain white. Float in a wash of Transparent Yellow.

2 Paint Green Areas
Apply Oxide of Chromium to the green areas.

3 Paint Black Areas
A mix of Alizarin Crimson and Phthalo Green can be added to the black areas; avoid the glistening whites.

4 Finish the Wings
Paint the yellow, glistening highlights with Transparent Yellow. Leave the white of the paper showing through where the wings appear white. Some areas seem to have a blue tinge. Add a touch of Phthalo Blue to these. A pale wash of Indian Yellow can be laid in over the wings and shadow. Draw in the wing veins with a thinly pigmented mix of Alizarin Crimson and Phthalo Blue.

Materials

- Arches 140-lb. (300 g/m²) hot-pressed watercolor paper
- Schmincke watercolors
 - Phthalo Green
 - Alizarin Crimson
 - Phthalo Blue
 - Indian Yellow
- Winsor & Newton watercolors
 - Transparent Yellow
 - Oxide of Chromium
- no. 4 da Vinci sable brush

Ladybugs

My most often painted insect is the ladybug—you may have noticed! So much so, it's almost become my trademark. I sometimes hear disappointment when a viewer has searched amongst the petals, leaves and background only to find the painting ladybug-free! I love to have an insect emerging from the mysterious dark of a background or shadow. Think of interesting perches on which to place your insects. Keep your colors and their complementaries in mind. A red ladybug on a green leaf looks stunning; a red ladybug on a pink petal is less obvious. Decide how prominent you wish your bug to be.

Materials

- Arches 140-lb. (300 g/m²) hot-pressed watercolor paper
- Schmincke watercolors
 - Indian Yellow
 - Cadmium Red Deep
 - Alizarin Crimson
 - Phthalo Green
- no. 4 da Vinci sable brush

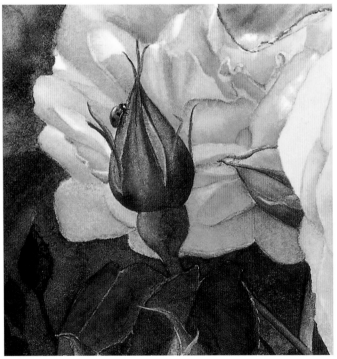

1 Lay In Wash
Decide where your highlights are to be placed. Lay in a wash of Indian Yellow.

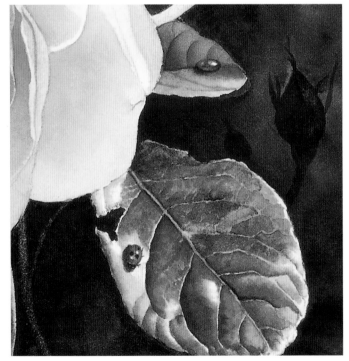

2 Deepen Wash and Add Spots
Once dry, apply a wash of Cadmium Red Deep. Now, using Alizarin Crimson, paint in the deeper red wash on the areas facing away from the light source. Mix a luscious black by combining Phthalo Green and Alizarin Crimson. Paint in the spots and head, leaving a highlight or two on the head.

detail
ROSE "GRAHAM THOMAS"
watercolor on Arches 140-lb. (300 g/m²) hot-pressed watercolor paper,
22" × 18½" (56cm × 47cm), private collection

Floral Dance

Here's your chance to incorporate some of the lifelike details you've just learned into a full painting. The majority of this study relies on gentle blending, resulting from floating in the color rather than the use of brushstrokes. It's the ladybugs, dewdrops, bright sunlight and shadows that make this painting seem alive. You can feel the warmth from the luminous reflected light glowing inside the flower trumpets. One droplet is about to fall from the petal—this positioning adds energy to the painting. The rich, luminous, dark background gives a mystery to the scene. Look carefully and you'll find two more ladybugs meandering along a stem, one about to disappear under a leaf. Give some thought to the placement of your details. I usually add these pièces de résistance once I've completed my painting. At this stage the best position is most obvious.

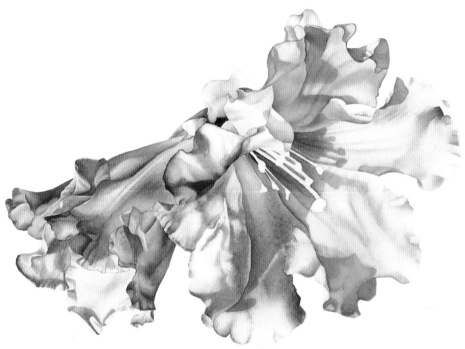

Materials

- Arches 140-lb. (300 g/m²) hot-pressed watercolor paper
- Schmincke watercolors
 - Cadmium Yellow Deep
 - Brilliant Purple
 - Indian Yellow
 - Burnt Sienna
 - Cadmium Red Deep
 - Cadmium Orange Deep
 - Alizarin Crimson
 - Ultramarine Blue Finest
 - Phthalo Blue
 - Phthalo Green
 - Payne's Gray Bluish
- Winsor & Newton watercolors
 - Naples Yellow
 - Transparent Yellow
- Maimeriblu Sap Green
- no. 4 and no. 12 da Vinci sable brushes

1 Build Up Fine Washes

Using a no. 12 brush, build up fine washes until you are happy with the richness and depth of color. Be sure to use the priming method before each wash as gentle blending is essential with this study. I used an initial, very fine wash of Indian Yellow. The reds I chose for this study were Brilliant Purple and Alizarin Crimson. My shadow color was predominantly Ultramarine Blue Finest, although I did add a touch of Sap Green in warmer shadow areas. I usually find it preferable to complete the petals by painting in the local color before adding the shadow. Don't forget to soften the edges of the shadow to avoid those hard, unnatural edges. I like to bring each petal near completion before I move on to another, giving the feeling of achievement at a reasonably early stage. This also sets the overall tonal value (the *key*) for the painting, giving me a range of values to work within to minimize the amount of adjustment later.

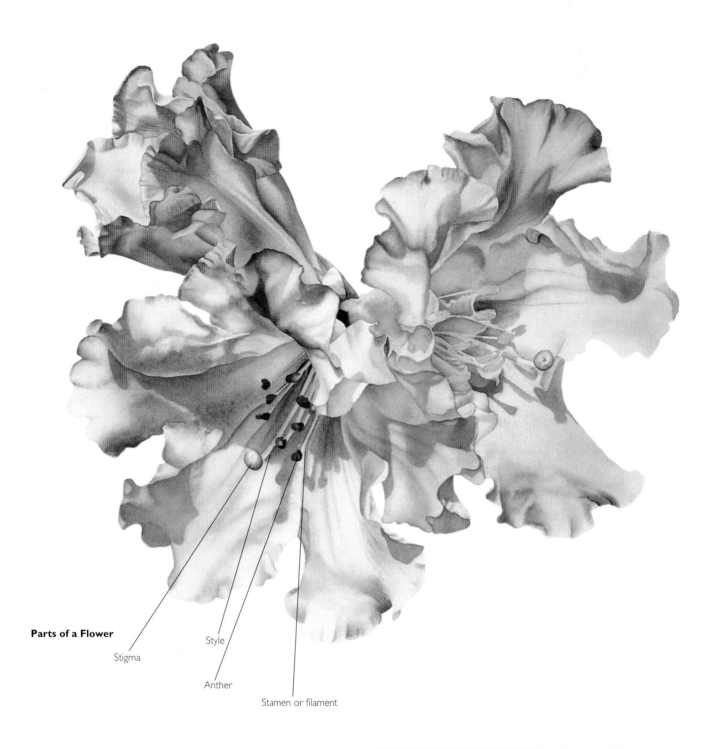

Parts of a Flower

Stigma

Style

Anther

Stamen or filament

2 Make Your Subject Glow

Describe the last petal using the same fine wash technique. Change your brush to a no. 4 sable. The stamens were painted with a fine wash of Naples Yellow, enriched with a touch of Alizarin Crimson or Indian Yellow where required, especially at the base. Note how luminous the throat of the trumpet is. I used three different colors to achieve this, each in different areas, laying them alongside each other: Transparent Yellow, Cadmium Yellow Deep and Cadmium Orange Deep. This will give a luminous glow, indicating light penetrating the outer petal and illuminating the trumpet throat. Paint the anthers with an initial wash of Cadmium Yellow Deep, leaving a touch of white for a highlight. A fine wash of Burnt Sienna will give richness, and the final touch is Ultramarine Blue Finest mixed with a little Burnt Sienna for a shadow color.

Don't Overcompensate for Background Colors

As you work, bring your colors to the depth you feel is necessary. Don't overcompensate for the power of the background or neighboring subjects. It's safer to add extra depth to color at the final stage if you find that the background has overpowered your colors. Removing color in large sections can destroy the gentle blending you've achieved.

3 *Give the Leaves Texture*

These rhododendron leaves require particular attention to detail. They are quite distinctive and give the plant interest and character. An initial wash of Transparent Yellow gives a cool glow. I divided the leaf into ridges and then again into segments. Wet a segment with clear water. Wait until the sheen has only *just* disappeared (i.e., damp).

Re-wet the areas that need the deepest color within the segment. Drop in Sap Green and allow to disperse. Once you've built up the depth you require, move on to another segment—but not one directly next to the segment you just worked on.

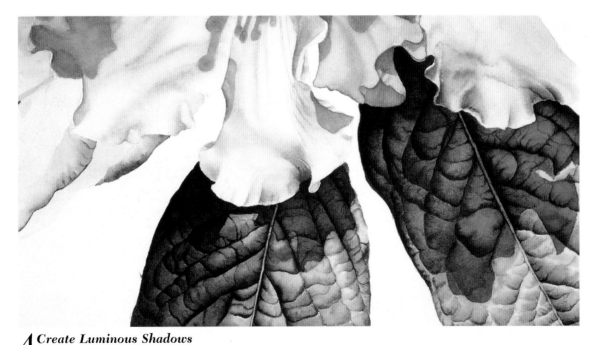

4 *Create Luminous Shadows*

Complete the leaf, adding the shadows only when you've finished. Apply your shadows using the priming method. Drop in your shadow mix. Create more depth directly below the petals. A rich, transparent shadow color can be mixed using Sap Green, Phthalo Blue and a touch of Alizarin Crimson. Soften the shadow edges slightly to give a natural look. Remember, shadows are transparent. To achieve this illusion, once the shadow wash dries, re-paint some of the detail (such as muted veins and highlights) that have been lost due to the application of the shadow wash.

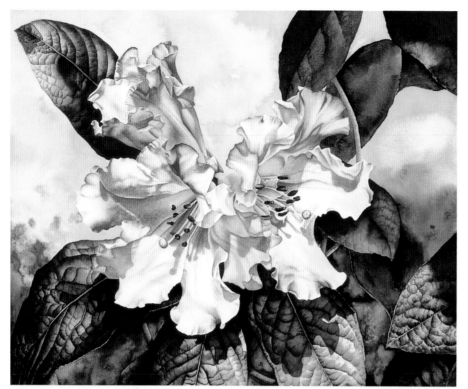

5 Underpaint Your Background

A rich wash of Transparent Yellow over the entire background glows through any subsequent transparent wash. I toyed with the idea of adding additional details in the background (such as the orange and purple flowers) but decided it detracted from the beauty, detail and form shown in the petals and leaves. (Should you wish to add these background flowers to another painting, I painted the orange flowers wet-into-moist using Indian Yellow, Burnt Sienna and a spot of Alizarin Crimson. I painted the blue flowers with Ultramarine Blue Finest, a touch of Sap Green and a little Payne's Gray Bluish.)

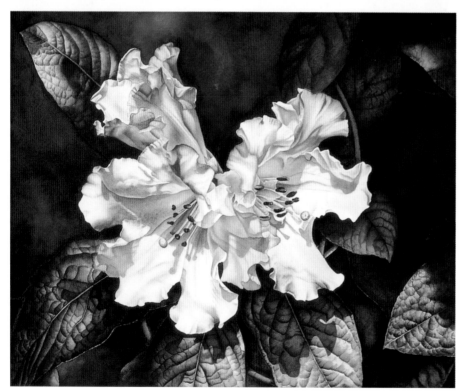

6 Create a Dark Foil

I love how a dark foil, as in this background, can push the subject forward. I built up several fine layers, starting with the Transparent Yellow underwash. A wash of Sap Green was then applied, followed by several washes of Payne's Gray Bluish. These are all transparent colors and add to the illusion of depth and background interest. The very dark areas had a little Alizarin Crimson added to give variety and a slight change in color temperature. I felt areas still needed further defining. You will note a subtle variation between the background of this step and the final painting. This is due to extra washes of Payne's Gray Bluish and Alizarin Crimson. This small amount of fine-tuning pushed the bloom farther forward and made the background appear deeper.

7 Add an Extra Dimension With Dewdrops

Now we're ready to add life to the painting. As I chose to leave the placement of dewdrops and ladybugs until the end, I didn't save a highlight area where they will appear. Instead, I used an electric eraser to lift the color for the highlights. You could also scratch the highlight out with a sharp knife *after* you've finished the dewdrop or ladybug, or use a fine bristle brush to lift the pigment. I wet the dewdrop, avoiding the highlighted area, then dropped in a light wash of Transparent Yellow. Once this was dry, I re-wet the area with less water, avoiding that precious highlight again. Keeping in mind the area farthest away from the light source will be darker, once the paper reached a damp stage, I let a fine wash of local color (Brilliant Purple for the flower dewdrops and Sap Green for the leaf droplets) flow into the droplet, starting at the very edges. This allows the deepest color to remain at the outer rim.

Placing Details

Choose natural positions for your insects and droplets. A drop about to fall gives the painting energy. A ladybug crawling along a stem almost out of view adds a little mystery to the painting.

8 *Add Dewdrop Shadows and Ladybugs*

Lightly dampen the area where the dewdrop shadows will fall. Float in a shadow mix of Alizarin Crimson and Ultramarine Blue Finest for the petal droplet and Sap Green, Phthalo Blue and Alizarin Crimson for the leaf dewdrop. Now decide the best perch for your foraging ladybugs. Lay in a glaze (wet-on-dry) of Cadmium Yellow Deep; cadmiums are opaque pigments that have excellent covering power. Now add a glaze of Cadmium Red Deep, allowing a thinner layer on the side closest to the light source. Alizarin Crimson will give form to the areas requiring depth. Finally, a shadow mix of Sap Green and Alizarin Crimson will give a luminous shadow color on the body. A cooler mix of Phthalo Blue, Sap Green and Alizarin Crimson is best for the cast shadow on the stem or leaf. Lightly soften the shadow edge. Paint the black spots with a velvety mix of Alizarin Crimson and Phthalo Green. Use a knife or fine stiff brush to lift a small amount of color for a highlight, or use a drop of white body color.

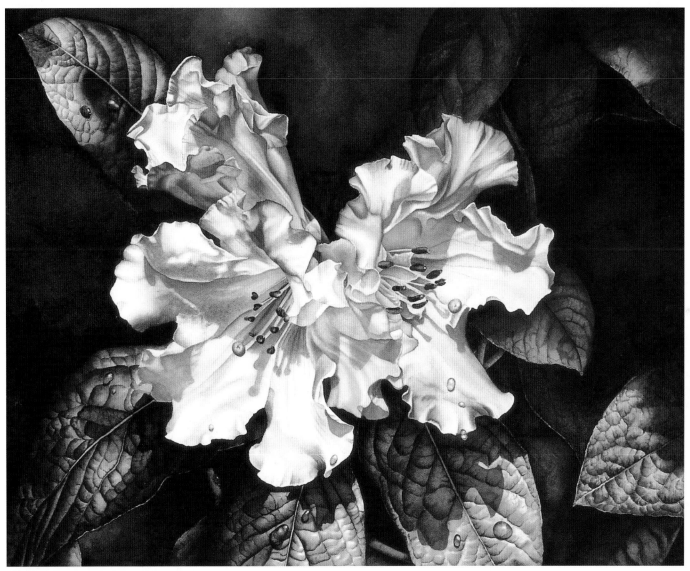

9 Fine-Tune

Invariably, I find colors need enriching at this stage. Once the depth of background color is built up, the main subject is perceivably paler, even though it may have looked strong and vibrant previously. Compare the finished piece with step six—notice how effective merging the background over the far side of petals can be. To ensure the flower achieves the illusion of actually coming out of the background, we need to gently blend some of the background color over the edges. This has the effect of pulling the far side of the petal back into the painting and gives an added depth previously missing. Painting petals individually, as we have done, can sometimes look a little unnatural. I gently lay in a wash of clear water over the individual flowers (the flowers need to be completely dry) to unify the bloom and soften edges that appear too prominent.

RHODODENDRON "FLORAL DANCE"
*watercolor on Arches 140-lb. (300 g/m²) hot-pressed watercolor paper,
15½″ × 20″ (39cm × 51cm), private collection*

Enough Is Enough

Sometimes it's hard to know when to stop. Step back and look at your painting. If the overall effect "feels right," then it is right. A good test is to put it aside for a few days and look at it with a new and rested eye. If time is short, hold it up in front of a mirror—it's amazing how this gives a new perspective on the work.

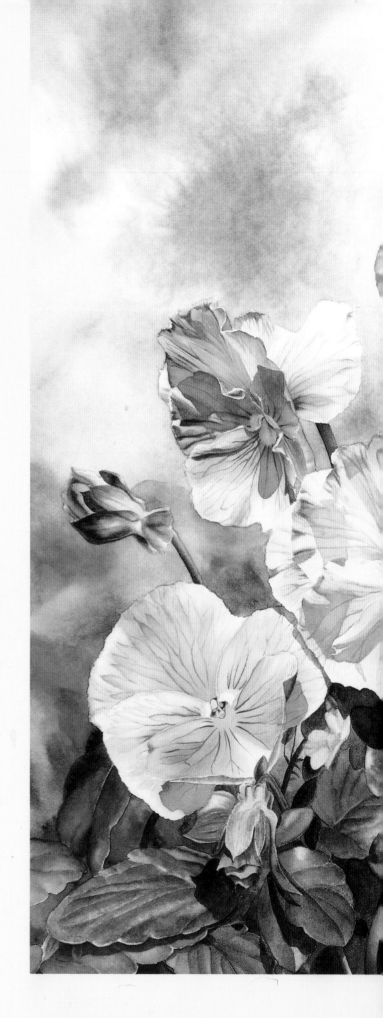

Painting Florals
With Character

What is it about a flower that catches your eye and moves you to paint it? Color, form, light and shadow may all factor into its appeal, but you must look beyond the physical aspects to see the "soul" of the flower as well. The character of a flower is what makes the bloom appealing. Keep in mind the feelings you have about a flower and the atmosphere you wish to create in your painting; a successful composition needs to portray those feelings.

HIGH SUMMER
watercolor on Arches 140-lb. (300 g/m²) hot-pressed watercolor paper, 18½″×21″ (47cm×53cm), private collection

Where would the cottage garden be without pansies, the essence of summer? I love to watch a gentle breeze ruffle the petals so they waft around like butterflies. The bright sunlight highlights the upper petals, throwing rich, glowing shadows across the petals beneath. The deeply ribbed leaves were quite a challenge, demanding many washes to build up the depth and richness of color but still retain the highlights. The use of bright sunlight gives the impression of lazy, hot summer days.

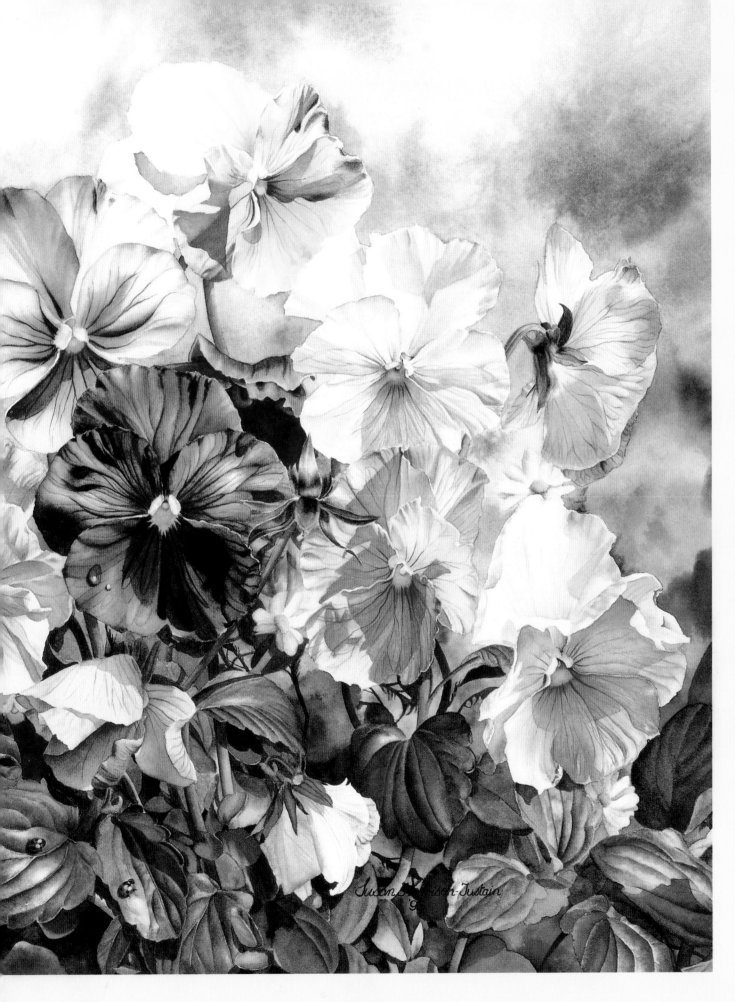

Susan Scheewe-Justain '9

Host of Golden Daffodils

Have you ever seen a "host of golden daffodils"? What do you feel when you remember them? This flower has an almost stoical strength in defiance of the last winter cold. Notice the bold, vibrant yellow of the central petals reflecting onto the outer petals, strongly influencing their color. See how the petals fall at different angles? Some petals are ribbed, while others have soft folds that catch the light to create gentle highlights. I've chosen an angle more pleasing than a head-on composition. This study evolves from the gradual buildup of fine, lightly colored washes. Spend some time studying the photograph below and analyze the colors that are actually there. How often is a yellow petal just yellow (its local color)? Sunlight and shadow affect the local color, as do reflected and filtered light.

Planning Your Painting

Before you start a floral study, decide if you will only be painting the main flower or flowers, or if you will be adding background and taking it to a completed painting. If you choose the latter, you must plan ahead when choosing the quality and size of your paper. When I began this demonstration, I used a large enough piece of paper to enable me to add some extra daffodils and a background.

Materials

- Arches 140-lb. (300 g/m²) hot-pressed watercolor paper
- Schmincke watercolors

 Cadmium Yellow Deep

 Phthalo Blue

 Alizarin Crimson

 Cadmium Orange Deep

 Permanent Red Orange

 Permanent Lemon Yellow
- Winsor & Newton watercolors

 Naples Yellow

 Aureolin
- no. 2, no. 4 and no. 12 da Vinci sable brushes (Use different sizes interchangeably as you feel comfortable.)

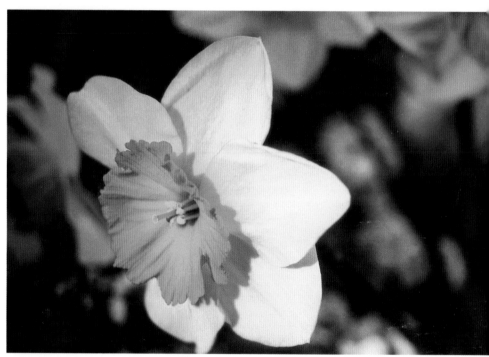
Reference photo

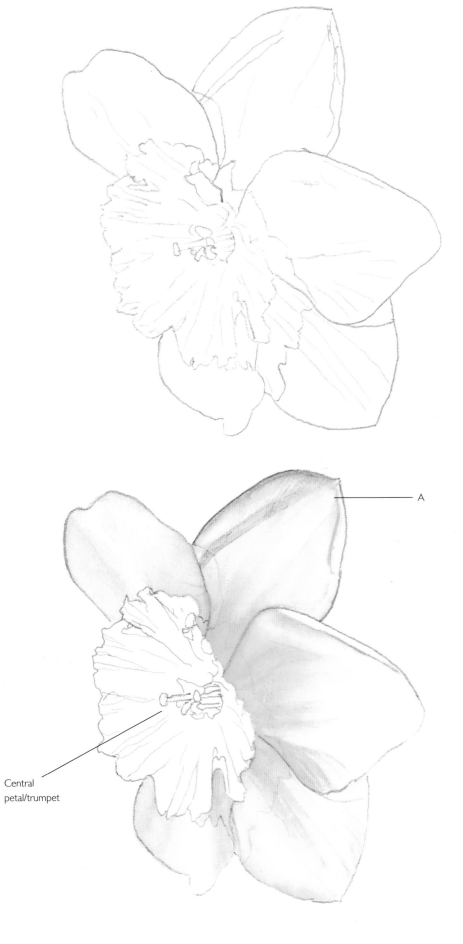

A Quick Reminder of the Priming Method

1. Wet area.

2. Allow paper to absorb water, but not dry.

3. Wet brush with clear water.

4. Touch brush gently to a rag to remove excess water.

5. Wet area again.

Now you are ready to apply color.

1. Apply pigment to chosen area.

2. Allow paper to dry completely between applications.

If the water has been absorbed before you've had time to add all the pigment you require, dry completely and re-peat process.

A

Central petal/trumpet

2 **Lay In Washes**
Naples Yellow—used here for its warmth—is generally opaque, but it is transparent in a very fine wash. Lay this wash over all of the petals except the central trumpet (this requires opaque yellows and oranges, so adding a fine wash at this stage is unnecessary). I like to make the local color beneath a shadow quite rich so the luminosity glows through once the shadow color is applied; working the outer petals one at a time, prime petal A, and drop in Cadmium Yellow Deep in the area where the center petals reflect back into the outer petal. Let pigment flow gently toward, but not up to, the edge of the wet area.

3 Paint Shadows and Center

Look at the reference photo. Where are the deeper yellow, blue, orange, greenish and gray-pink shadows? Paint them with the same technique just used for the yellow. Greenish areas are Phthalo Blue with Aureolin; push them warmer by adding more yellow, or cooler by adding more Phthalo Blue. Gray-pinks are Alizarin Crimson and a touch of Phthalo Blue—use Alizarin Crimson sparingly in this study. Try color mixes on a scrap of paper before applying them to your painting. Keep in mind that the areas at the crests of folds are high-lighted, as on petal B, so the white needs to be preserved. Soften the edges directly next to highlights with a damp brush (one with most of the moisture squeezed out of it). Flatten the brush between your fingers and run it down the line when the shadow color has only just been absorbed. This doesn't disturb the shadow color as long as your brush is no damper than the paper (refer to page 41 on capillary

reaction). Petal A has a ridge that needs to retain a harder edge. Dampen the area to be worked, just exceeding its edges. Let it almost dry (less moisture equals harder lines), then dampen again. Apply a wash of Aureolin by running your brush along the lower edge of the crease. The dampness pulls pigment to the upper edge, becoming less dense as it approaches the top. Ribs and veins can be included at this stage. Dampen the petal; using a no. 2 brush with a small amount of pigment and moisture, stroke the vein line beginning at the innermost point of the petal. If the line is too hard, quickly soften it with clear water, remembering to flatten your brush. The cast shadow edges are softened with the same technique.

Prime the center petals, then lay in a heavily pigmented wash of Cadmium Yellow Deep. Allow to dry.

Use Two Brushes to Soften Edges

I like to have two brushes on hand when working fine lines or softening edges: One is dipped in clear water and squeezed until just damp, while the other holds the pigment. Once you have laid down your pigment, run the clear water brush along the very edge to soften lines or weaken color. Oh to be ambidextrous!

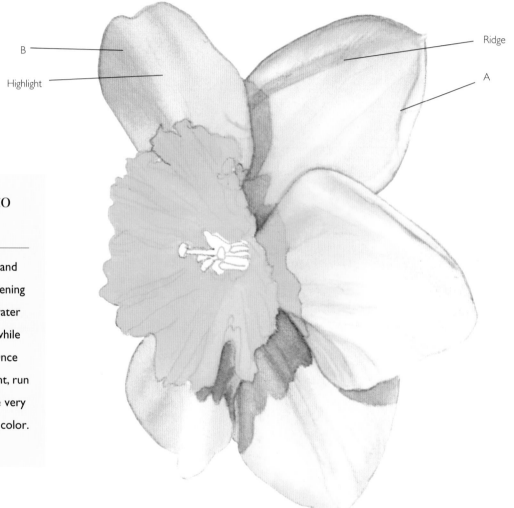

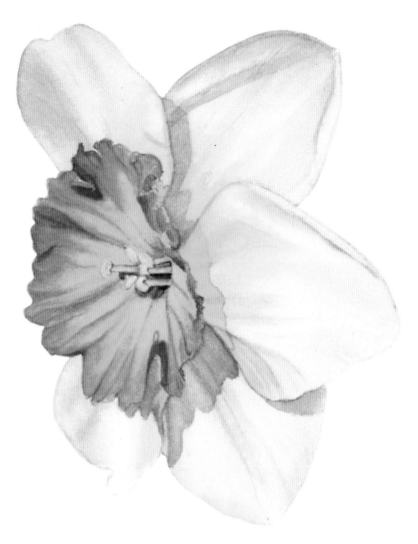

4 Continue Working Center

Wet the outer edges of the central trumpet again and drop in Cadmium Orange Deep. If you work fast enough, you can brush Permanent Red Orange into the darker folds and unlit areas. Once this is dry, put in shadows and veins. Use the same technique as for the veins on the outer petals, using a mix of Aureolin and a touch of Phthalo Blue for the veins that are a more grayish green, and Alizarin Crimson and Phthalo Blue where the veins are redder. Apply additional washes of Alizarin Crimson and Phthalo Blue to the deepest shadows. Lightly paint each stamen individually with a wash of Lemon Yellow and allow to dry. This cool yellow will set them apart from the warm trumpet. It's a good idea to keep referring back to the reference photograph. Add a light wash of Cadmium Yellow Deep sparingly where the stamen filaments are warmer; there is a deep red area where the filament meets the anther for which Alizarin Crimson is ideal.

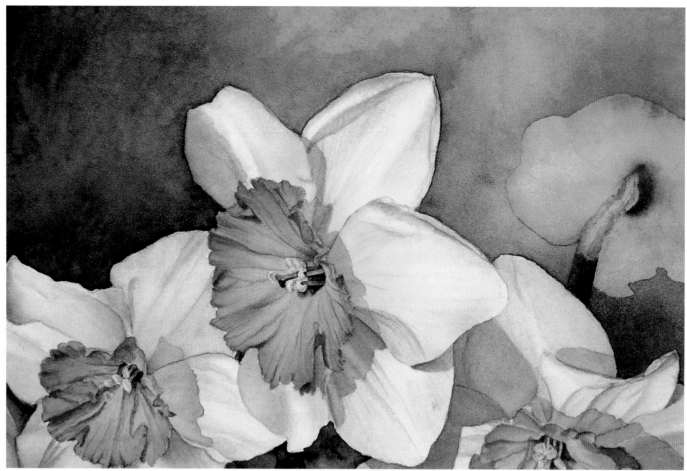

5 Complete the Study

Paint the bottom of the filaments with varied washes of bright green made from Phthalo Blue and Aureolin. Again, wet the area first with a little water and then add your color to get a blended look. Working each stamen filament separately, *very lightly* deepen one side with a shadow mix of Alizarin Crimson and a touch of Phthalo Blue. The anthers are painted by moistening the area with clear water and dropping in very fine washes of color. A very pale mix of Phthalo Blue and Aureolin is used for the cooler side, while very pale washes of Lemon Yellow Light give you a clean, light yellow for the warmer side. I like to add areas of color deeper than found naturally at the base of the stamens, usually behind the front stamen filaments. This pulls the area back and pushes the lights forward. For this dark area use a mix of Alizarin Crimson, Aureolin and Phthalo Blue.

Because the petals are painted individually, the edges sometimes need softening to make them appear part of the whole flower. I like to gently wash over my flowers with clear water once the painting is complete; this gives a softness and uniformity to the bloom. *Only do this where you have used transparent pigments.* If you washed over the central trumpet (painted with opaque pigment), you would lift the color and loose your detail.

You may wish to add a background as shown (refer to pages 44-45 on backgrounds for some suggestions). If you're putting in a background, you may find that the areas of petal can be pulled into the background shadows by wetting them again and bringing the moisture over the edge of the petal, into the background. You can also bring some of the background color onto the petal, which gives a lovely soft edge. Rubbing out pencil lines also softens the edges of the petals.

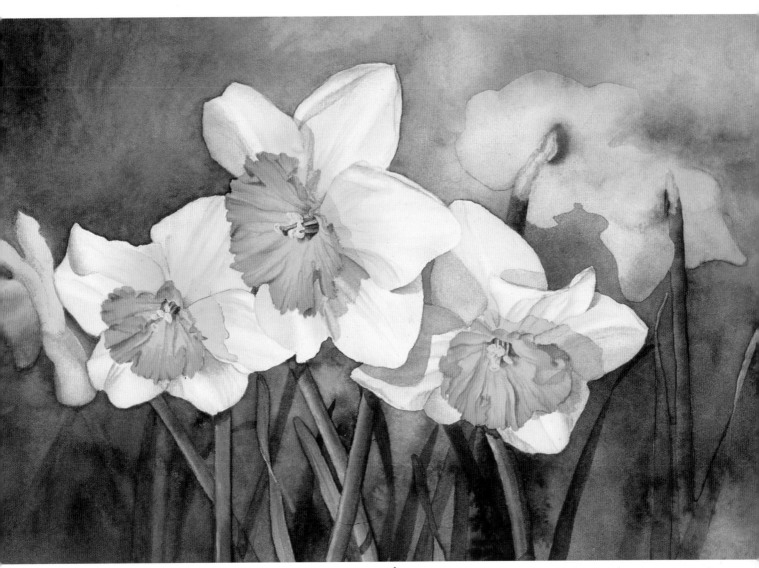

HOST OF GOLDEN DAFFODILS
watercolor on Arches 140-lb. (300 g/m²) hot-pressed watercolor paper,
6½″ × 10″ (17cm × 25cm), private collection

Give It Time

Put unresolved paintings aside for a few months, then take another look, armed with the new solutions and experience you have gained from successive paintings. The lessons you have learned will help you rescue a discarded work.

Constance Spry

The essence of this painting is light. Evocative of a warm summer's day, there is a clear blue sky and a gentle breeze disturbs the dewdrops as they lie basking in the dappled sunlight. This rose, called "Constance Spry," is the epitome of David Austin's English roses. This full cabbage rose is strikingly beautiful; she is delicate and yet has great strength, reminiscent of the old roses of the Dutch masters.

I have chosen to portray all of her stages, from a ripe, green bud to a bloom just a few days past its prime, revealing the richly colored stamens that can't be seen in newly opened blooms. Sunlight filters through the upper petals and leaves, gently illuminating the undergrowth. The blooms are a strong, prominent feature because I have surrounded them with deep, rich, complementary hues. The transparent dark background is offset by the flickers of light on the foreground leaves. The eye rests on the leaves and stems before being drawn into the mystery of the luminous background beyond.

This isn't an easy subject. Give yourself time and credit for each section as you achieve it. As you progress through the painting you'll become aware of the subtle changes in hue and will learn how to "read" the colors in front of you—which I feel is the single most important thing you can do for yourself. Practice with color mixes before you start. Learn to "push" the overall hue and temperature of a mix. When I'm painting a detailed piece such as this, I like to have another painting "on the go" so one painting doesn't become too important and my concentration on it too intense, creating unnecessary stress. Let's enjoy this piece and pat ourselves on the back at each milestone—it will only get easier as we proceed.

Materials

- Arches 140-lb. (300 g/m²) hot-pressed watercolor paper
- Schmincke watercolors
 Cadmium Yellow Deep
 Cadmium Red Deep
 Purple Brilliant
 Ultramarine Blue Finest
 Phthalo Blue
 Phthalo Green
 Alizarin Crimson
- Winsor & Newton watercolors
 Aureolin
 Permanent Rose
- Maimeriblu watercolors
 Sap Green
 Primary Yellow
- no. 0, no. 2, no. 4 and no. 12 sable or soft synthetic brushes if you prefer

Make Cutouts to Formulate Your Composition

I like to sketch my individual blooms on a rough piece of paper initially. I then cut out the blooms separately and arrange them on a piece of paper the size I intend to use for the finished work. I rearrange these cutouts until I'm happy with the composition and then transfer the composition onto good paper. This is a painless way to prevent any obvious compositional errors before they happen.

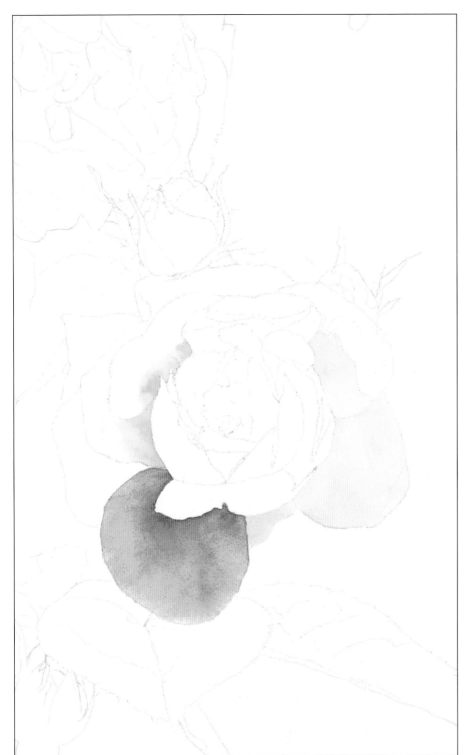

1 Lay In Initial Washes

Prime the entire rose with a no. 12 brush and clear water. Lay in a *very pale* wash of Aureolin and allow to dry. Now, working on each petal separately, use a no. 4 brush to prime areas that appear a deeper yellow and drop in a mix of Aureolin and Cadmium Yellow Deep. As you need to wait until each area is completely dry before you proceed, paint other petals that don't touch the drying ones while you have the required pigment on your brush. Once the initial petal is dry, prime again, but only dampen this time. Drop in a mix of Purple Brilliant and Permanent Rose, starting at the base of the petal as this is where the pigment is strongest. Allow the water to disperse the pigment up and over the petal. Tilt the paper slightly if it is flowing too freely from the base. Allow to dry, and repeat until you have the desired depth of color.

Hot Tip

Make yourself a hot drink, put on some of your favorite music and pamper yourself a little. It's all in the name of creativity! But do keep your hot drink away from your water container; brushes aren't improved by the odd dip or two, and neither is the hot drink!

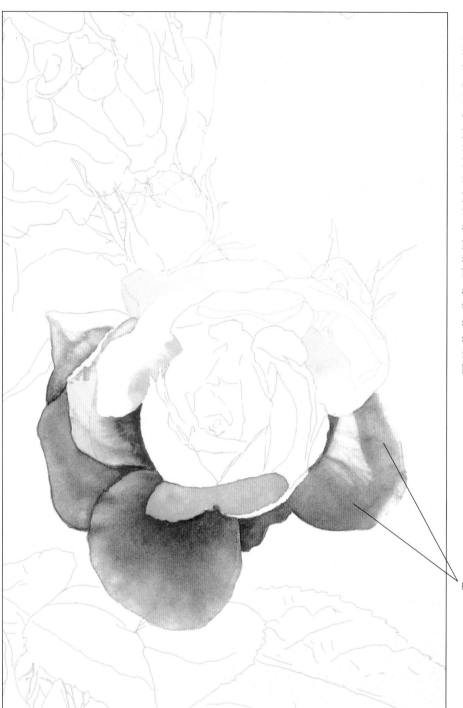

Petal 2 shadow area

2 Paint Luminous Shadows

Prime the area that requires shadow, adding a small extra margin to allow gentle gradation of pigment. Dampen just the shadow area, and drop in your shadow mix of Purple Brilliant and a touch of Ultramarine Blue Finest. Once again, slowly build up the depth of pigment. Work the other petals in the same manner, "reading" the depth of the yellow, Purple Brilliant, Permanent Rose and Ultramarine Blue Finest. The shadow on petal 2 is painted by wetting the area, plus a small extra margin. Now redampen the shadow area only and drop in your shadow color, letting the paper absorb the water and pigment until the sheen disappears from the surface. With a brush squeezed until just damp and wiped on a rag so there is minimal moisture left, run the brush along the shadow edge to create a soft, misty edge. Work the other petals in the same manner, building up depth of color with fine washes. Don't forget to preserve the highlighted areas.

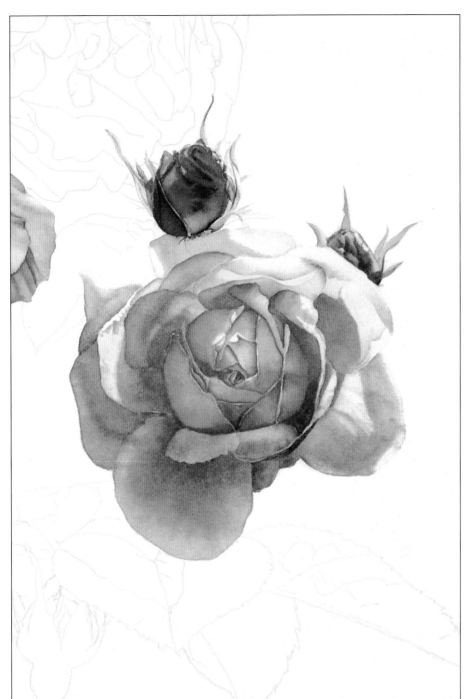

3 Paint the Buds

Using the same colors as for the bloom, build up washes over the buds. Using a no. 2 brush, lay in a wash of Aureolin over the sepals. Allow to dry, remoisten and add a wash of Phthalo Blue mixed with Aureolin. Keep light areas off-white or yellow. Add a touch of Alizarin Crimson to the front sepal. Use a mix of Phthalo Blue, Aureolin and Alizarin Crimson for the deeper shade. Run a brush slightly damp with clear water along areas that require dark lines. Run another fine brush loaded with the deeper shade along the dampened area. This will create a softly graduated line.

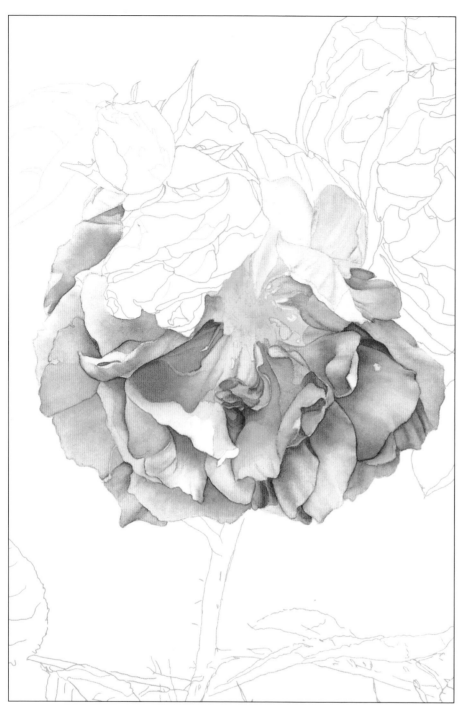

4 Make the Open Rose Glow

Use a no. 4 brush to build up layers on each petal, as with the previous bloom. I used Cadmium Yellow Deep for the area where the stamens are to be placed. A mixture of Cadmium Yellow Deep and Permanent Rose gives an orange glow to one side of the stamen area.

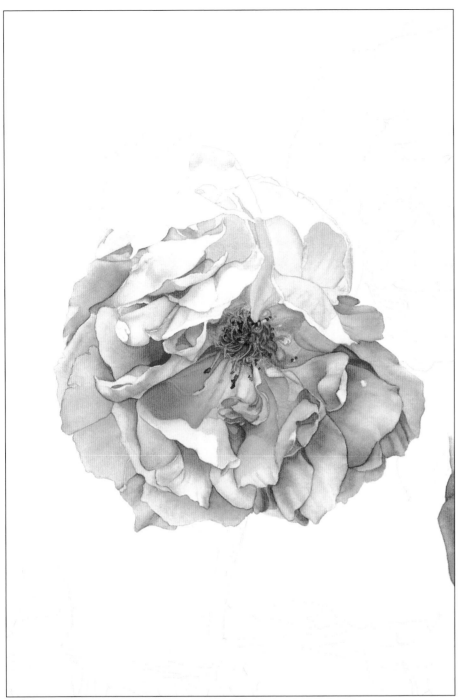

5 **_Paint the Stamens_**
After building up the color under the stamens, paint in the stamens using Permanent Rose, Ultramarine Blue Finest and Cadmium Yellow Deep. Using various combinations of these mixes, you can create form. Add more Ultramarine Blue Finest to the mix in the darkest areas. Use the same mixes in varied tones for the anthers. I use a very fine brush, no. 0 or no. 2, for this step. Remember to keep sunlight areas light.

6 Add a Bud With Reflected Light
With a no. 4 brush, paint the bud near the open rose, using the same layering technique as before. Add a touch of reflected light underneath this bud.

Reflected light

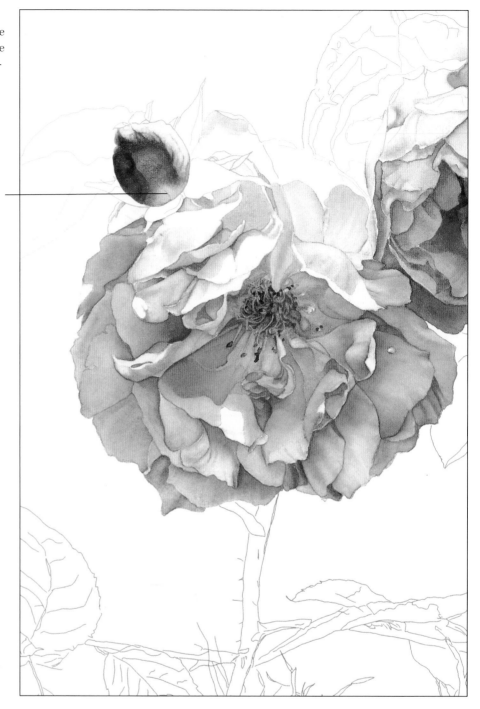

7 Make Your Inner Petals Glow

Continue to paint the outer petals as done previously. The central petals need to glow, so lay in washes of Cadmium Yellow Deep until there is a strong base color to work from. Remember, you must allow all washes to dry before adding subsequent washes. Next, introduce Cadmium Red Deep mixed with a small amount of Ultramarine Blue Finest and build up the washes until you feel satisfied with the glow. Allow to dry *completely* (either use a hair dryer or allow a few hours for the paint to really set). When dry, wash over the areas in shadow with clear water. Load your brush with a light mix of Cadmium Red Deep and a touch of Ultramarine Blue Finest and lay in a wash. The golden glow of the previous washes will shine through. While this is drying, you could paint in the leaf stems using consecutive washes of Cadmium Yellow Deep. Build up layers of Sap Green and Alizarin Crimson for a rich, deep, shadowed color.

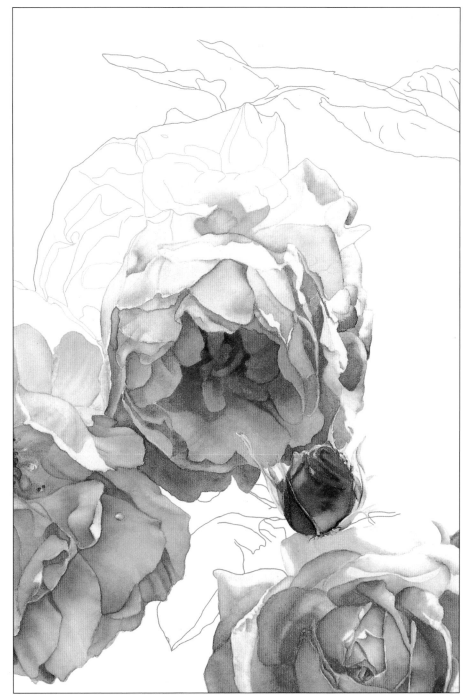

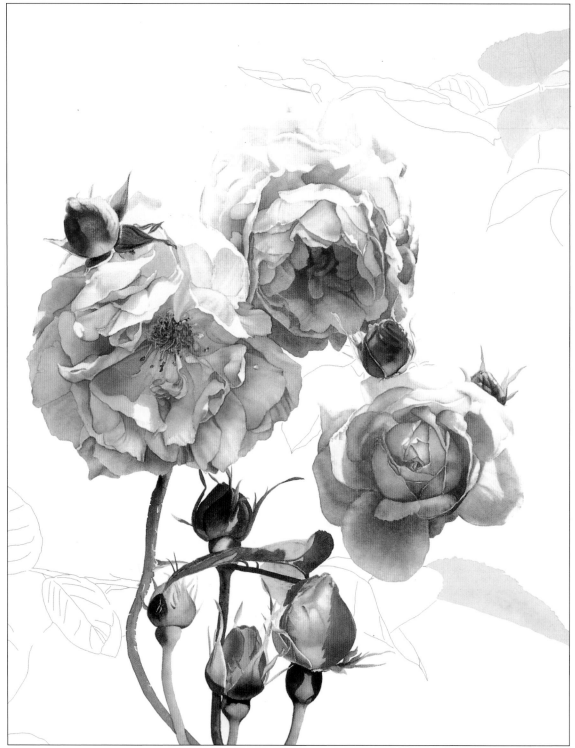

8 Paint Rose Thorns and Stems

Protect the rose thorns with masking fluid. I use a wet-in-wet technique for the stems. Using a no. 4 brush, lay in a wash of Cadmium Yellow Deep, then wash in Sap Green and lastly add a wash of Alizarin Crimson over the stem at the back. The Alizarin Crimson should be richer near the base of the stem. Mold your stems and buds with the use of warm and cool colors as shown. Paint the cool shadow areas with Phthalo Blue. Use a mix of Phthalo Blue and Alizarin Crimson for the deepest, warmest shadows. Intensify any wash that seems weak by adding further washes. Block in the leaves with Cadmium Yellow Deep.

Leaf I

9 Paint Leaves

Prime the entire first leaf except the rib at the base. Now drop in a wash of Sap Green, starting at the darkest edge. Allow the water to move the paint. Gently drop in lighter mixes of Sap Green in the lighter green areas. Leave some sections yellow. Work on the other leaves while the first one dries.

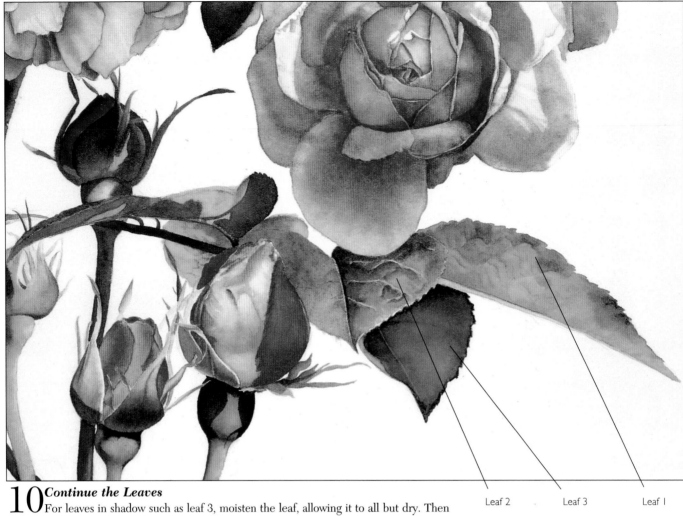

Leaf 2 Leaf 3 Leaf I

10 *Continue the Leaves*

For leaves in shadow such as leaf 3, moisten the leaf, allowing it to all but dry. Then dampen the paper again and wash in Phthalo Blue mixed with a touch of Alizarin Crimson. Now prime the first leaf again. Allow to almost dry, then redampen areas that require more color. Using a no. 2 brush, pick up Sap Green to define contours and veins on the leaf. The darker areas are a mix of Sap Green with a touch of Phthalo Blue and Alizarin Crimson. Work in the same manner on leaf 2, but keep the veins relatively free of green. Build up your washes to a deeper color at the base of the leaf as shown.

11 Complete Leaf Detail and Stems

Paint the rest of the leaves in the same manner. Once you have built up enough color in the areas shown, you'll find the detail emerges before your eyes. Enrich the main rose stem with more washes of Alizarin Crimson.

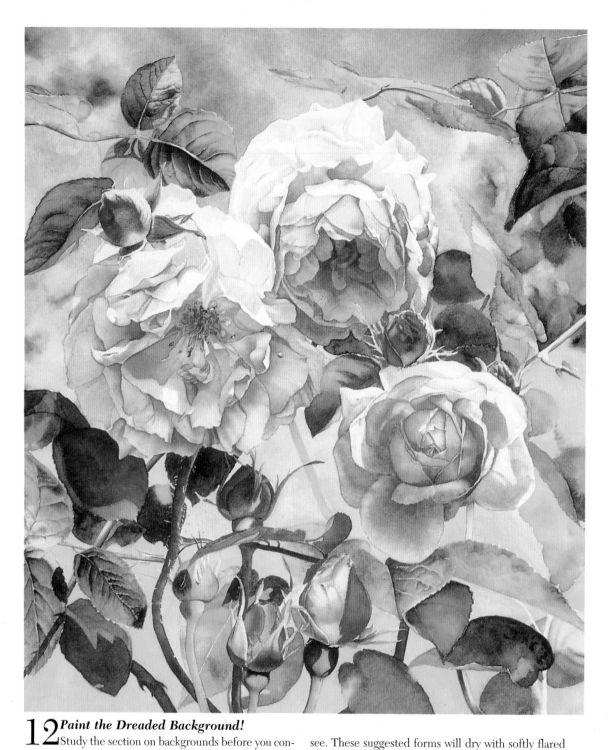

12 *Paint the Dreaded Background!*

Study the section on backgrounds before you continue (pages 44-45). It's a good idea to practice your background on a spare sheet of paper until you become accustomed to the techniques, as a poorly painted background can lose the "essence" of the painting. Foliage and stems at the base of the painting will act as natural breaks for your washes. Wet an area, then wash in Primary Yellow. Intensify if necessary. Continue until you have covered the base of the painting, working in sections as shown. You'll notice gentle, blurred leaves and a "suggested" rose in the background toward the top of the painting. This is achieved by priming the area and allowing an extra margin then remoistening it. Now drop in the different colors you

see. These suggested forms will dry with softly flared edges. If you find a hard edge is developing, run a brush that has been squeezed until only damp along the edges. Hard edges in the background will lose the illusion of distance. Once these areas have dried, move on to the sky. Wet the entire sky area with a large brush, and lay in a pale wash of Primary Yellow. Go over your "suggested" leaves and rose with this wash to help blend them. When dry, prime the sky area, taking care this time to avoid the suggested shapes. Lay in a wash of Ultramarine Blue Finest. Intensify with subsequent washes if needed. At this stage you could suggest other stems and leaves in the background if desired.

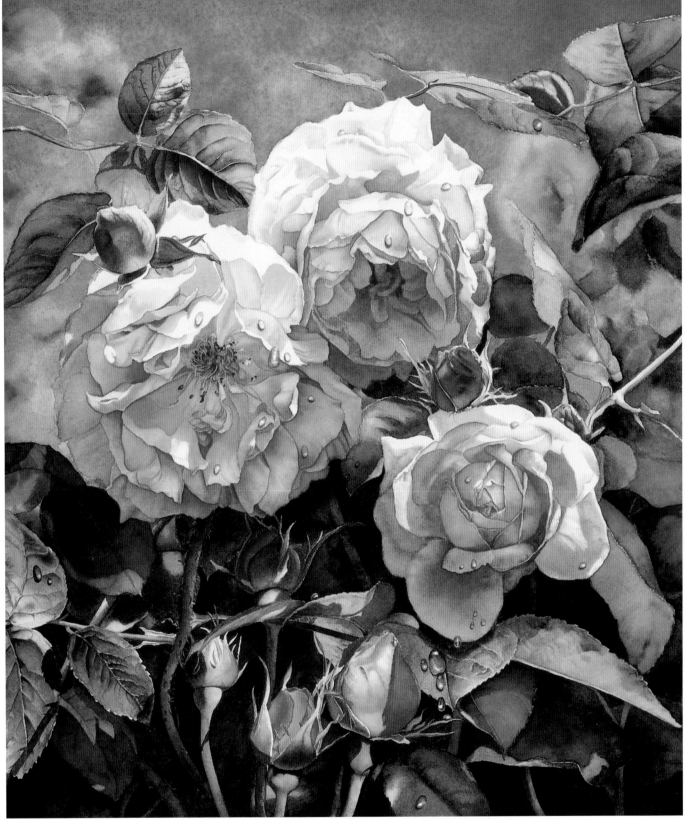

13 *Fine-Tune*

The rich, luminous darks are a varying mix of Alizarin Crimson, Phthalo Blue, Phthalo Green and Sap Green. Build these transparent darks with several washes. Notice how the dark background becomes a foil for the flickers of sunlight on the leaves. Remove the masking fluid and paint the thorns with Cadmium Yellow Deep then Cadmium Red Deep. Now add a light wash of Permanent Rose and Phthalo Blue to the shadowed thorns. Add some movement by painting in some dewdrops (see pages 74-77). You'll be amazed at how much you've learned in just this one study. The methods will stand you in good stead for many subjects.

ROSE "CONSTANCE SPRY"
watercolor on Arches 140-lb. (300 g/m²) hot-pressed watercolor paper, 20″ × 17½″ (51cm × 44cm), private collection

Gallery

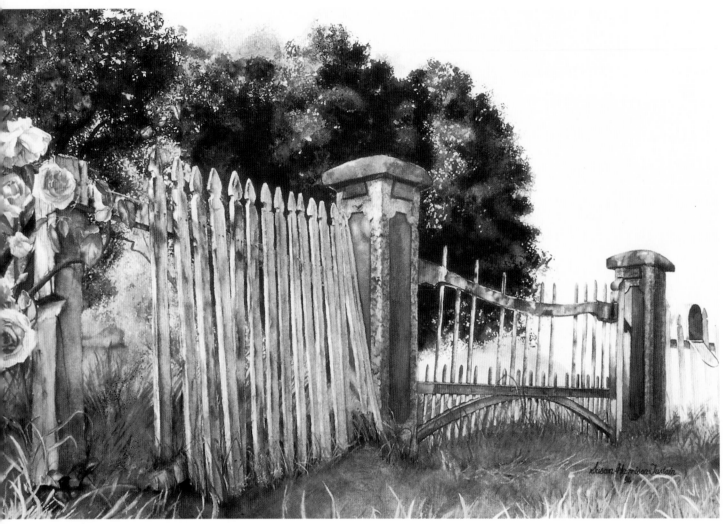

BEYOND THE GATEWAY
watercolor on Arches 140-lb. (300 g/m²) rough watercolor paper,
12¼″ × 18″ (31cm × 46cm), private collection

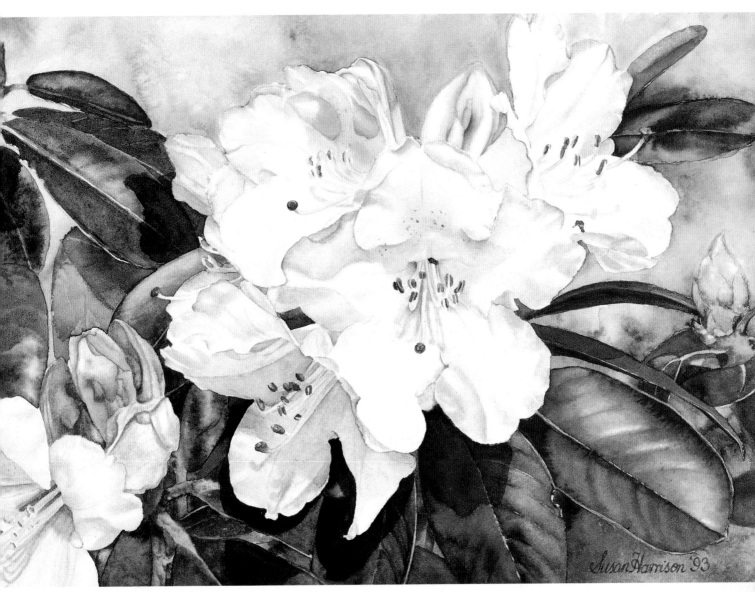

RHODODENDRON ''UNIQUE''
watercolor on Arches 140-lb. (300 g/m²) hot-pressed watercolor paper,
7½" × 11" (19cm × 28cm), private collection

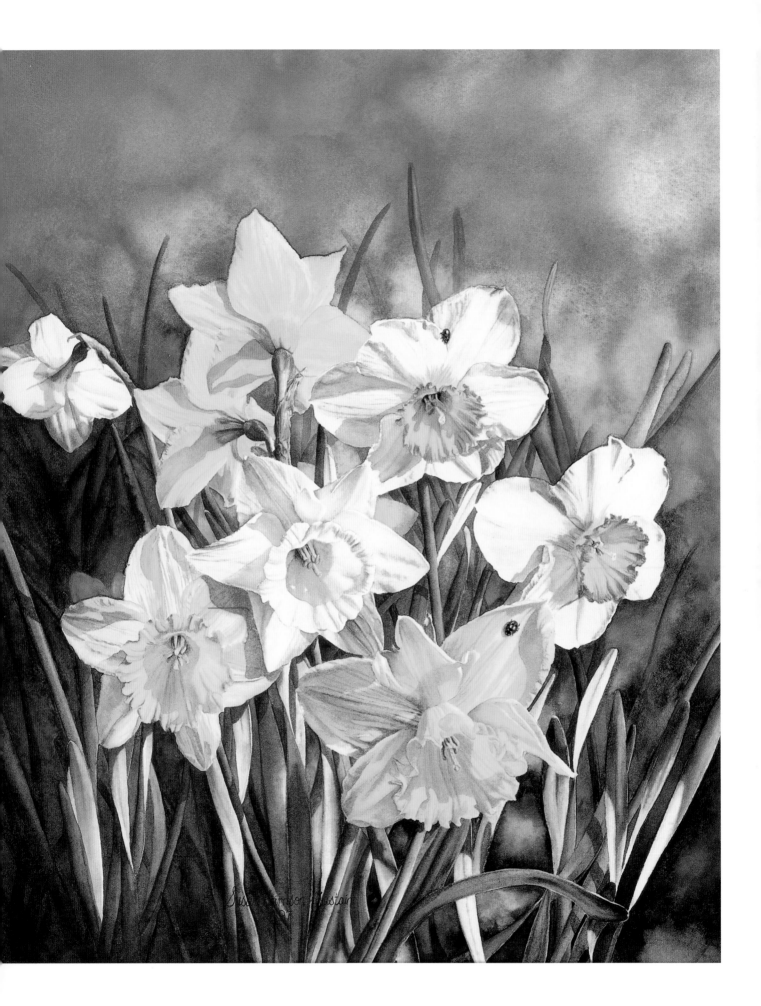

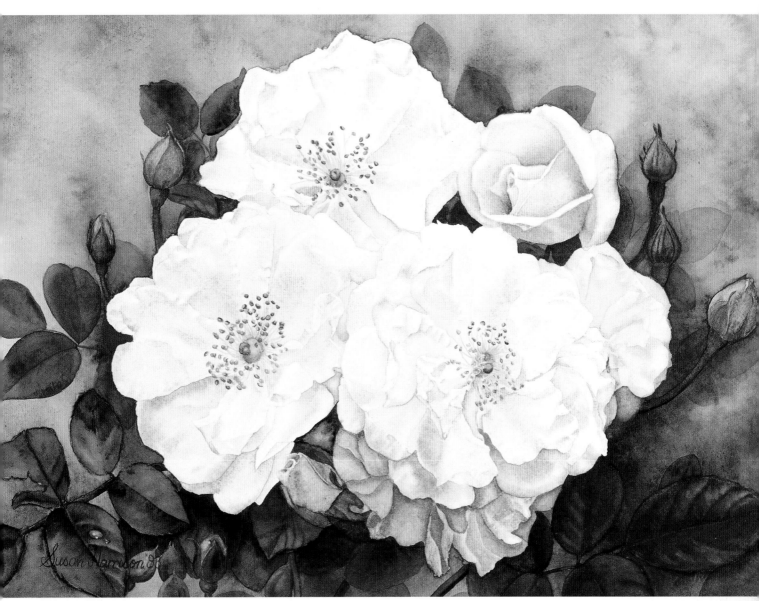

ROSE "ADÉLAIDE D'ORLÉANS"
watercolor on Arches 140-lb. (300 g/m²) hot-pressed watercolor paper,
14½″ × 19″ (37cm × 48cm), private collection

at left

CHAMP D'OR (FIELD OF GOLD)
watercolor on Arches 140-lb. (300 g/m²) hot-pressed watercolor paper,
18½″ × 15″ (47cm × 38cm), private collection

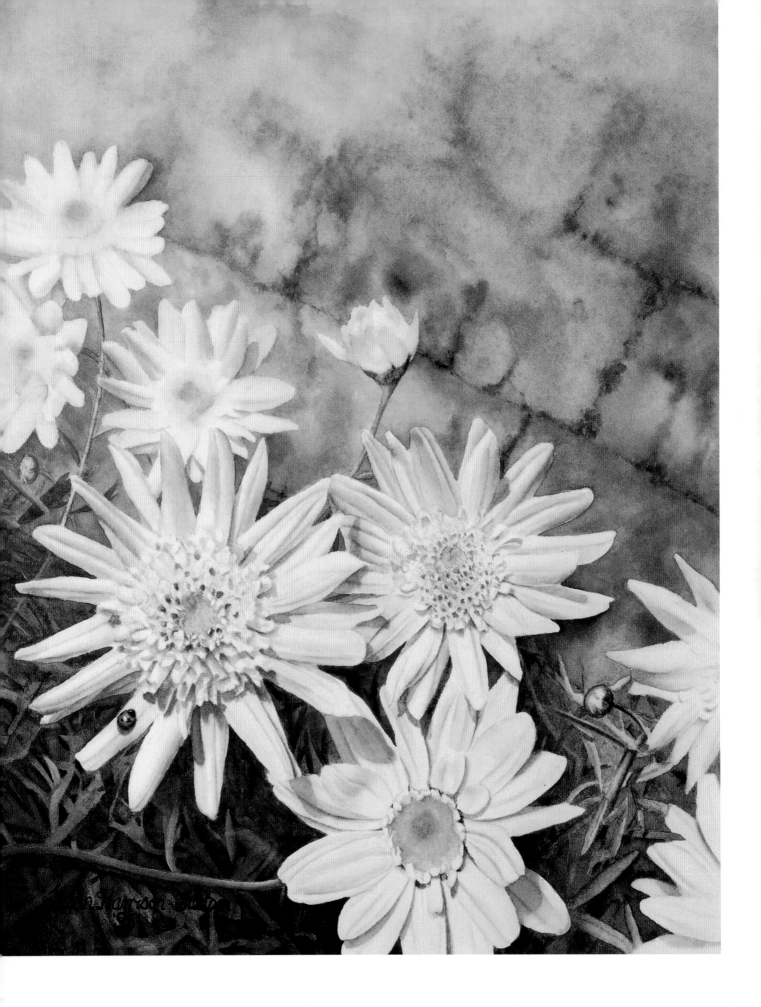

SAM AND ROSE ''FLOWER CARPET''
watercolor on Arches 140-lb. (300 g/m²) hot-pressed watercolor paper,
11"×16" (28cm×41cm), private collection

at left
DAISY A DAY
watercolor on Arches 140-lb. (300 g/m²) hot-pressed watercolor paper,
14"×11" (36cm×28cm), private collection

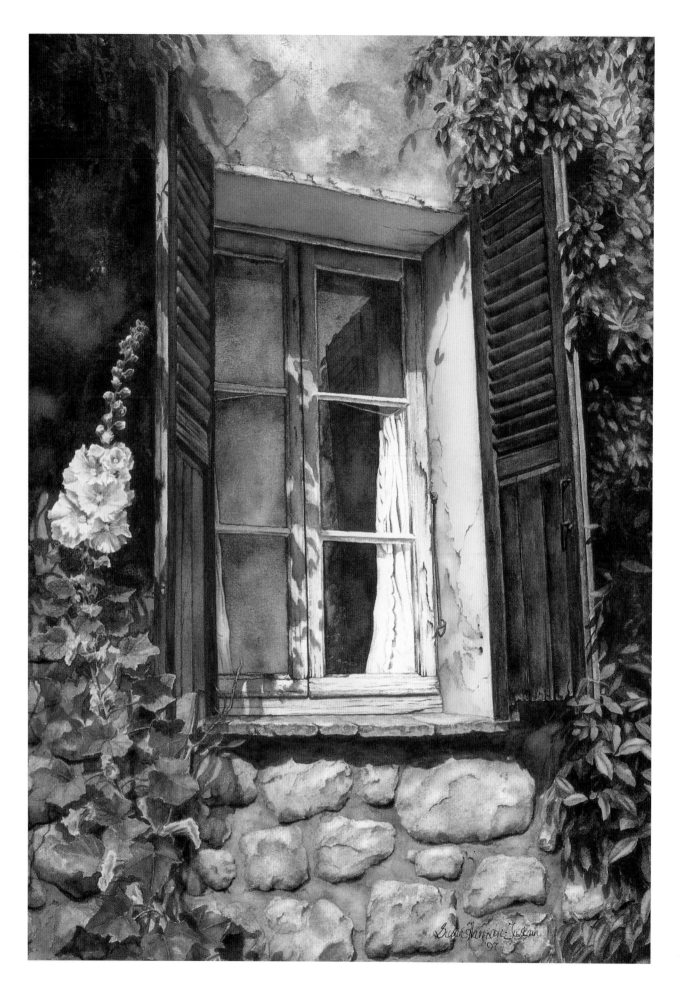

Writing this book has required me to give a great deal of thought to many things, practical and philosophical. We need to lose the inhibitions created by the restrictions normally associated with watercolor. Without the constraints of rules and boundaries, we are free to discover so much more. I've included suggestions—learned by trial and error—to make your journey easier. Take the time to think about all the *other* possible applications for each demonstration. For example, how "light against dark" can give depth to a vein in a leaf or character to a crack in a rustic, decaying wall; how "suggesting" a rose in a background can give focus to the main subject, as well as added depth to the background, indicating the subject is part of nature's "bigger picture"; and how rich, translucent dark mixtures can add mood, atmosphere and mystery to one subject and give the impression of deep, luscious undergrowth for another.

In writing this book I've analyzed why I do things in a certain way, why some things work and others don't, but the major revelation has come with the analysis of the psychological effect discovering art has had on me and, I hope, on others as well. We often hear of people "finding themselves"—arriving at a new and exciting place in their lives. This can happen with the discovery of the artist within. We then see the world with artists' eyes and realize how magical the "commonplace" is. The saying "take the time to smell the roses" makes us realize how much we've missed in the days before we were serious about painting.

I love to walk in unspoiled forest and smell the fresh, clean air; to gaze up to the canopy above and delight in the dappled sunlight filtering through the leaves; to see how the light changes the greens from opaque to almost translucent. My artist's mind analyzes the colors, and I'm filled with excitement at the thought of reproducing this wonderful feeling. And that's the *essence* of painting. It's not just reproducing what is in front of us; it's arousing our senses and filling the senses of others (the viewers and patrons of our work), so much so that we become lost in the world of the painting and the painting becomes the reality.

THE BIRD FEEDER
watercolor on Arches 140-lb. (300g/m²) hot-pressed watercolor paper, 22″ × 14½″ (56cm × 37cm), private collection

I remember walking through a beautiful cottage garden and chancing across a gentle statue of "The Bird Feeder." I was so moved by him that I spent most of the afternoon drawing studies, making color sketches and shooting a number of films for reference—I ran out of time to explore the rest of the garden! This was one of those "must paint immediately" subjects. I hurried home and spent the next few weeks totally absorbed in the painting. My passion for the subject and intense study was well repaid. I thought I had captured what I had felt on first seeing the statue: the dappled, flickering light dancing across his molded hair, the delicate rose branch swaying in the gentle breeze (well, actually I used a little artistic license for these roses; they were rambling over a summerhouse in a previously seen part of the garden). The huge foxglove leaves, enjoying the respite from the heat of the day, came out of the painting to greet me, and the delicate, old world geranium leaves gave a softness and a gentle movement as if fluttering around the statue's feet and brushing against his legs.

On my return to the garden several months later, I made a beeline for the spot where my "friend" was resting, preparing myself along the way for déjà vu of the senses. I turned the last corner and saw the statue, but, oh, the disappointment! The reality wasn't as evocative as the painting. To me, the painting had become the reality and evoked more passion than the statue had probably ever done. I learned a great lesson: It is emphasizing the essence of our subjects that evokes the passion in us all, and isn't it this passion that we all strive to capture?

I hope, with this book, I have not only shown you how to reach your goals by showing you a number of techniques but, more importantly, also shown how to give your subjects a spirit. I like to think of it rather like leading you to a window, throwing it open and allowing you to discover a whole new world of your own creativity.

May your paintings and their creation fill your soul with joy.

Susan

FENÉTRE DE PROVENCE (WINDOW ON PROVENCE)
watercolor on Arches 140-lb. (300 g/m²) rough watercolor paper, 22″ × 15″ (56cm × 38cm), private collection

A

Antique Shades, 80
Arches hot-pressed paper, 17, 30
 See also Materials lists

B

Background
 adding, to daffodils, 102
 blended, 44
 Constance Spry, 116
 effects of, on flower, 36
 opaque, 45
 overcompensating for, 90
 under leaf, 78
 underpainting, 92
Beyond the Gateway, 118
Bird Feeder, The, 125
Blacks, rich, 85
 mixing, 33
Blending, 39
 backgrounds, 44
Blotting paper, 18
Bountiful Harvest, 25
Branches, burnt sienna for, 26
Brandy and the Monarch Butterfly, 7
Brights, 37-38
Brushes, 16
 two, to soften edges, 100
Bumblebees, 82-83
Butterflies, 84-86

C

Capillary reaction, 40-41
Champ d'Or (Field of Gold), 120
Cicadas, 87
Color(s)
 basic, laying in, 64
 building up, 66
 dropping in, 76
 local, 55
 push-pull of, 48
Color theory, 37
Complementary mixes, 37
Composition, 11
 cutouts to formulate, 104
Constance Spry, 104-117
Cutouts to formulate composition, 104

D

Daffodil Days, 84
Daffodils, 98-103
Daisy a Day, 122
Damp brush, to soften edges, 40

Darks, mixing, 34
Demarcation lines, softening, 50
Details, 11
 building, 83
 butterfly, 86
 placing, 93
 suggested, 50
Dewdrop
 extra dimension with, 93
 on leaf, 74-75
 on petal, 76-77
Dimension
 creating, with value, 48
 extra, with dewdrop, 93
Drybrush, 32

E

Edges
 lost and found, 42
 shadow, 46, 49
Edges, softening, 40
 with two brushes, 100
 See also Demarcation lines, softening
Eraser, electric, 18

F

*Fenétre de Provence (Window on
 Provence)*, 124
Fine-tuning, 50, 95, 117
 bumblebees, 83
 defined, 71
Flaring. *See* Blending
Flower(s)
 center, 56, 63
 character of, 96
 effects of background on, 36
 purple, shadows for, 76
 withered, 80-81
Foil, dark, 92
Folds
 emphasizing, 65
 and veins, 60-63
Form
 leaf, 70
 modeling, 47
 molding, 85
Form, building up, 61
 with washes, 55, 61

G

Gator board, 18, 19
Glazes, for insects, 82
Granulated effects, 26

H

High Summer, 96-97
Highlight
 lifting out, 62
 planning, 74
 and shadow, 61, 75, 77
Host of Golden Daffodils, 103

I

Iris "Memphis Delight," 39

L

Ladybugs, 88
 adding, 94
Leaves
 chewed, 78-79
 dewdrop on, 74-75
 rose, 113-115
 smooth and shiny, 70-71
 texture, 91
 veined, 68-69
 warm and cool sides of, 68
Light, reflected, bud with, 110
Lights, washes for, 36
Lines, black, softening, 85
Local color, defined, 55
Luminous Tapestry, 46

M

Magnolia Officinalis, 52-53
Maimeriblu paints, specific, 15, 22-23
Masking fluid, 17
 for stamens, 55
Materials lists
 bumblebees, 82
 butterflies, 84, 86
 chewed leaves, 78
 cicadas, 87
 Constance Spry, 104
 creased petals, 64
 delicate petals, 54
 dewdrop on leaf, 74
 floral dance, 89
 folds and veins, 60-63
 golden daffodils, 98
 ladybugs, 88
 leathery petals, 58
 shiny leaves, 70
 veined leaves, 68
Mixing
 blacks, 33
 brights, 37
 transparents, 22

Modeling form, 47

O

Old Rambling Rose, 2-3, 81
Opaque colors, 24
 backgrounds, 45

P

Paint box, 18
Painting
 completed, 95
 planning, 98
Paints, 14-15
 See also Color(s); Palette; Pigments,
 performance of
Palette, 17
 limited, adding to, 34
 paints on, 12, 14-15
Papaver Orientale, 28-29
Paper, 17
 planning for, 98
 stretching, 19
 See also Blotting paper
Pencil, erasing, 24
Petals
 creased, 64-67
 delicate, 54-57
 leathery, 58-59
 rims, 59
Pigments, performance of, 14, 20
Planning, 98
Pommes Sur Bois (Apples on Wood), 38
Practice, importance of, 11, 39
Priming, 30, 99
 defined, 54
 soft edges, 40

Q

Quality, paint, 14

R

Rags, painting, 18

*Récolte de Provence (Harvest of
 Provence)*, 49
Redouté, Pierre-Joseph, 57
Rhododendron "College Pink," 12-13
Rhododendron "Floral Dance," 95
Rhododendron "Unique," 119
Rose "Abraham Darby," 20-21
Rose "Adélaide d'Orleans," 121
Rose "Adélaide d'Orleans2," 36
Rose "Constance Spry," 51
Rose "Graham Thomas," 35
Rose "Parade," 10
Rose "Troilus," 72-73

S

Sam and Rose "Flower Carpet," 123
Schmincke brand
 masking fluid, 17
 paints, 15, 22-23
Sedimentary colors, 26
Shadows, 46, 49, 55, 56, 61, 64, 65, 100
 dewdrop, 94
 and highlight, adding, 75, 77
 luminous, 46, 91, 106
 for purple flowers, 76
 on rust, 47
Stamens
 daffodil, 101-102
 poppy, 62
 rose, 56, 109
Stems, 67
Stems, rose, 115
 and thorns, 112
Style, own, vs. other artists, 11
Subject, essence of, 125
Sunlight, amount of, 49

T

Thorns and stems, 112
Transparency, heightening, 46
Transparent colors, 22-23
 dark, mixing, 34

U

Underpainting, background, 92
Underwashes
 bumblebee, 83
 opaque, 24
 transparent, 22

V

Value, creating dimension with, 48
Veins
 folds and, 60-63
 leaf, 69

W

Washes
 fine, 89-90
 initial, 105
 laying in, 54, 60, 68, 70, 85, 87, 88, 99
 opaque, 58
 over opaque color, 24
 shadow, 56
 See also Underwashes
Washes, building up, 30-32
 for lights, 36
Water
 amount of, for washes, 30
 clear, adding wash of, to finished
 painting, 102
Wet-in-wet, backgrounds, 44
Wet-on-dry, 32
Wet-on-wet, 32
White-on-white, 43
Wings
 butterfly, 85-86
 cicada, 87
Winsor & Newton paints, specific, 15, 22

Y

Yellow, underwashes, 22, 24, 44

More Books for Creating Great Art!

Painting Watercolor Portraits that Glow— Jan Kunz's expert instruction, along with her own glowing portraiture examples, make this book an all-time favorite. Order yours and get Jan's secrets for painting accurate, lively, colorful portraits in 11 step-by-step demonstrations. You'll learn how to accurately draw the head and facial features, create the illusion of three-dimensional form; apply the laws of light to render brilliant darks, capture character and more. #31336/$23.99/160 pages/200 color, 200 b&w illus./paperback

Painting Nature in Pen & Ink with Watercolor— Claudia Nice is your guide on a treasure hunt through nature. Follow her clear, friendly instruction to paint birds, butterflies, fish, shells, flora and fauna . . . all the small, fantastic wonders of forests, tropical reefs, mountains, deserts, swamps and wildflower fields. This unique, light-hearted book is filled with sketches, notes, tips and step-by-step demonstrations—all leading to full-length projects alive with the joy of nature. #31193/$27.99/128 pages/100 color, 16 b&w illus.

Splash 5: The Glory of Color— From the deep, moody blues of Bermuda to the simple poetry of a bright red watering pitcher, from delicate washes to thick, bold strokes, Splash 5 celebrates masterful and inventive uses of color. You'll see 125 paintings from 109 of today's finest watercolor artists. Along with the beautiful reproductions, you'll find insights from the artists on the colors they use, and how you can use color to bring emotion, sensation and energy to your work. #31184/$31.99/144 pages/130 color illus.

How to Get Started Selling Your Art— In plain language, Carole Katchen tells you how to make a living—or just earn some spare cash—as an artist. You'll learn how to display your art attractively, establish prices, develop professional-looking business cards and stationery and assemble a portfolio. This book also describes the pros and cons of co-op, membership and juried shows, as well as galleries and art festivals. #30814/$17.99/128 pages/paperback

Watercolor: You Can Do It!— Besides being a fine artist, Tony Couch has a real knack for explaining complicated concepts in a simple, visual way. In this book, Couch teaches you what it took him years to learn, including how to compose a painting by thinking in terms of shapes and symbols; use just 10 basic hues to create all the colors you need; paint trees, skies, water, waves, rocks and grasses; and more! #30763/$24.99/176 pages/160+ color, 150+ b&w illus./paperback

The Art of Painting Animals on Rocks— Lin Wellford shows you how, with acrylic paint and imagination, you can turn ordinary rocks into incredible works of art! This book contains 11 step-by-step projects that are easy, creative and just plain fun. Each project includes patterns and photos of the finished piece. Follow along, changing colors and designs as you like. You'll find ideas and inspiration in the many color photos of Wellford's own rock creations. #30606/$21.99/128 pages/250 color illus./paperback

Perspective Without Pain— Designed to help you solve depth problems easily. You'll learn 6 techniques of perspective, how to portray rect-angular objects in linear perspective, and how to develop your ability to handle the ellipse, the cylinder and the slant. #30386/$19.99/144 pages/185 color illus./paperback

The Watercolorist's Complete Guide to Color— You'll learn how colors in paint behave; how to mix colors; wash and glazing techniques; how to "charge" one wet color into another; and how to choose a palette. Ten step-by-step demonstrations show color found in shadows, a white subject and a colorful subject, water, clouds and skies—plus how to paint nature's greens, intensify a color's brilliance, create distance with color and more. #31106/$23.99/144 pages/200+ color illus./paperback

The Watercolor Painter's Solution Book— This visual solution book will help you recognize and identify problems in your work by showing you paintings with specific problems and how to solve each one. With this book, you'll soon be stepping back to take a look at your work and find yourself smiling at the results. #30307/$21.99/144 pages/200+ color illus./paperback

Exploring Color, Revised Edition— In this book, you'll learn the different characteristics of each pigment and when (and in what combinations) it's best to use them. Leland includes 83 clearly defined exercises that show you how to use color to plan stronger designs, create greater interest, develop better compositions, create striking harmonies, and convey powerful moods and emotions. Along with the examples, this book is richly illustrated with the works of many masters of color. #31194/$24.99/144 pages/244 color illus./paperback

Painting Fresh Florals in Watercolor— Learn Arleta Peck's simple secrets for creating elegant, realistic watercolor florals. She'll show you how to layer colors to create a wealth of rich hues. (She's even included a handy color wheel of glazes for quick reference.) Next, step-by-step demonstrations will show you how to use glazes to paint magnolias, dogwood, daffodils, tulips, irises, roses, peonies, apple blossoms, leaves, lace and china. #31182/$27.99/128 pages/220 color, 17 b&w illus.

Zoltan Szabo's 70 Favorite Watercolor Techniques— Szabo has perfected 70 tried-and-true techniques over more than 60 years of painting. With this book, you can use the techniques in your work immediately for great effects. The techniques are presented in short, easy-to-follow lessons with step-by-step demonstrations showing many of the techniques applied. #30727/$28.99/144 pages/230 color illus.

Painting Beautiful Watercolors from Photographs— Jan Kunz shows how to create great watercolor paintings inspired by photos. Eight complete painting demonstrations illustrate specific techniques for working with photos of flowers, children, animals and other subjects. Nine before-and-after demos present problem photos that intrigued Jan and how she turned them into successful paintings. #31100/$27.99/128 pages/208 color, 58 b&w illus.

The Artist's Photo Reference Guide to Flowers— You'll find gorgeous photos of 49 different types of flowers arranged alphabetically, from Amaryllis to Zinnia. Each flower is shown in a large primary photo, along with side views and close-ups of petals, leaves and other details. Many of the flowers are shown in an assortment of colors, too. Five step-by-step demonstrations in a variety of mediums show how you can use these reference photos to create beautiful floral paintings. With this unique book, you can use your precious time for painting, not research. #31122/$28.99/144 pages/575 color photos

Basic Techniques for Painting Textures in Watercolor— The seasoned advice in this book will help you "make your strokes strong, free and direct . . . and let texture happen." A compilation of some of the finest teaching on the subject ever published by North Light Books, this book contains art, advice and step-by-step instruction from 20 outstanding artists—including Carole Katchen, Claudia Nice, Zoltan Szabo and Frank Webb. In addition to exploring a range of texturing techniques, you'll learn to see runs, raindrops and other "accidents" as potential parts of your design. #31104/$17.99/128 pages/320 color illus./paperback

Painting Sunlit Still Lifes in Watercolor— Liz Donovan's watercolor still lifes are anything but still. They are infused with the sparkle, color and movement of sunlight. In this book, Donovan shows you how to capture the magic of sunlight in your watercolors. In 33 step-by-step demonstrations, you'll learn how to paint a variety of popular still-life elements, including lace, velvet, patterned fabric, glass, copper, silver, wood grains, marble textures, apples, peonies, irises and leaves. Includes great advice on choosing objects and arranging your still life, an easy preliminary drawing method, and four complete step-by-step painting projects. #30900/$28.99/144 pages/235 color illus.